OUT THERE

The Open Museum: Pushing the boundaries of museums' potential

First published in 2010 by Culture and Sport Glasgow
(Glasgow Museums)

ISBN 978-0-902752-94-8

Authors

Elaine Addington, Nicola Burns, Alastair Callaghan,
Sarah Cartwright, Claire Coia, Nat Edwards, Fiona Hayes,
Chris Jamieson, Mary Johnson, Kevin Kerrigan, Seoyoung Kim,
Catherine Laing, Janice Lane, John MacInnes, Lyndsey Mackay,
Crawford McGugan, Morag McPherson, Laura Murphy,
Mark O'Neill, Alex Robertson, Lindsay Robertson, Tawona Sitholé,
Julian Spalding, Jaime Valentine, David Walker

Edited by Fiona MacLeod
Designed by Trish Copson
Photography supplied by Glasgow Museums' photographers and
Photolibrary.
www.glasgowmuseums.com

Printed in Scotland by Allander.
www.glasgowlife.org.uk

Front cover image: *Winds of Change*, c.1990, wood. TEMP.20404.
Back cover image: the Open Museum's van and staff at
Cranhill Beacon.

Acknowledgements

All efforts have been made to trace copyright holders but if any
have been inadvertently omitted, please notify the publishers.
The publishers gratefully acknowledge the following for permission
to reproduce illustrations:

Mr Uddin, p.79
Illustrated London News, p.105
The Jeely Piece Club, p.47
The Mitchell Library, pp.86
National Library of Scotland, pp.108–109
Newsquest (Herald & Times), pp.84–85, 86

Our Museums

The Burrell Collection

The collection is named after its donor, the shipping magnate
Sir William Burrell. It is one of the greatest collections ever created
by one person, comprising over 8,000 objects.

Gallery of Modern Art

Housed in an elegant eighteenth-century neo-classical building in the
heart of Glasgow, the Gallery of Modern Art (GoMA) offers a thought-
provoking programme of temporary exhibitions featuring cutting-edge
contemporary work by local, national and international artists.

Glasgow Museums Resource Centre

Glasgow Museums Resource Centre (GMRC) is the store for the city's
priceless collections.

Kelvingrove Art Gallery and Museum

Scotland's most visited attraction is a magnificent building with
22 themed, state-of-the-art galleries displaying an astonishing
8,000 objects.

Museum of Transport

The Museum of Transport has closed in preparation for the opening
of the new transport museum on the Clyde – Riverside Museum.

The People's Palace

The People's Palace, set in historic Glasgow Green, tells the story
of the people and city of Glasgow from 1750 to the end of the
20th century.

Provand's Lordship

Step back in time and discover Glasgow's unique history with a
visit to the oldest house in the city. Provand's Lordship was built in
1471, originally as part of a hospital, and is one of only four medieval
buildings to survive in Glasgow.

Scotland Street School Museum

Scotland Street School was designed by Glasgow's most celebrated
architect, Charles Rennie Mackintosh, and was a functioning school
up until 1979. Now a museum, it tells the story of education in
Scotland over a hundred years, from the late 19th century to the late
20th century.

St Mungo Museum of Religious Life and Art

The award-winning St Mungo Museum is a haven of tranquillity in
a bustling city. Its galleries – full of displays, artefacts and stunning
works of art – explore the importance of religion across the world and
across time.

CONTENTS

PREFACE

Ellen McAdam,
Acting Head of Museums
Glasgow Museums / Glasgow Life

The Open Museum team practises the curatorial equivalent of parkour. They do not actually run free across the rooftops and through the underpasses of Glasgow carrying objects to users: in reality they drive a van and conscientiously observe the requirements of collections care. They were set up to operate outside the traditional parameters of museum practice, but after 20 years the principle of the user-led service has sunk deeply into the collective consciousness of Glasgow Museums. Nevertheless, there is still something subversive and exciting about the Open Museum.

The team is based in Glasgow Museums Resource Centre. This gives them access to a million objects, an extraordinary resource for public engagement and community involvement. The Centre is also home to Glasgow Museums' Research section, the only one of its kind on a civic museum service in the UK. The section is dedicated to developing collections-related research and publication in order to ensure that the content we offer the public uses the best available information and the most stimulating ideas. The potential for exchange and collaboration between these two sections as they work on the largest and finest civic collection in the UK is only just beginning to be explored.

But being part of an organization as big and varied as Glasgow Life opens up a new landscape to explore. Working with the Area Teams will enable the Open Museum to work its seditious magic much more widely, passing on its methodologies to reach more communities across the city. And the midnight runners will be carrying offers from the full range of cultural activities, not just from museums but from libraries, the arts and the concert halls. This museum will indeed be a temple to all the muses. To see what we can achieve through this expansion in breadth and depth, come back in 20 years.

Elaine Addington
Open Museum Curator
Glasgow Museums / Glasgow Life

Dr Nicola Burns
Policy and Research Officer
Glasgow Life

Alastair Callaghan
Outreach Assistant
Glasgow Museums / Glasgow Life

Sarah Cartwright
Outreach Assistant
Glasgow Museums / Glasgow Life

Claire Coia
Open Museum Curator
Glasgow Museums / Glasgow Life

Nat Edwards
Senior Curator, Open Museum
1993–2001
Currently Director, Burns National
Heritage Park

Fiona Hayes
Open Museum Curator 1990–98
Curator of Social History
Glasgow Museums / Glasgow Life

Chris Jamieson
Open Museum Manager
Glasgow Museums / Glasgow Life

Mary Johnson
Outreach Assistant
Glasgow Museums / Glasgow Life

Kevin Kerrigan
Learning Assistant
Glasgow Museums / Glasgow Life

Seoyoung Kim
Assistant Conservator 2003–08
Currently Metalwork, Arms and
Armour Conservator,
The Wallace Collection, London

Catherine Laing
Outreach Assistant
Glasgow Museums / Glasgow Life

Janice Lane
Learning & Access Manager,
Glasgow Museums / Glasgow Life

John MacInnes
Design and Technical Officer,
Glasgow Museums / Glasgow Life

Lyndsey Mackay
Open Museum Curator
/ Venue Technician
Glasgow Museums / Glasgow Life

Crawford McGugan
Open Museum Curator
Glasgow Museums / Glasgow Life

Morag McPherson
Open Museum Curator / Manager
2000–06
Currently Principal Learning and
Community Officer, Tyne & Wear
Archives & Museums

Laura Murphy (neé McGugan)
Open Museum Curator / Manager
1998–2002
Currently working with Melbourne
Museum, Australia

Mark O'Neill
Director of Policy, Research and
Development
Glasgow Museums / Glasgow Life

Alex Robertson
Open Museum Curator 1993–98
Curator of Social History
Glasgow Museums / Glasgow Life

Lindsay Robertson
Assistant Conservator of Furniture
and Frames
Glasgow Museums / Glasgow Life

Tawona Sitholé
Poet, Seeds of Thought

Julian Spalding
Former Head of Glasgow Museums
1989–98
Author, Curator and Critic

Jaime Valentine
Chair, OurStory Scotland
Honorary Senior Research Fellow
University of Stirling

Dr David Walker
Research Fellow
Scottish Oral History Centre
University of Strathclyde

Introducing Out There

Chris Jamieson
Open Museum Manager
Glasgow Museums / Glasgow Life

Out There is a celebration of the Open Museum process in its twentieth anniversary year – a celebration of expanding the possibilities of what a museum is and can be and a celebration of the power of objects and the people who have been involved.

It is set in the context of the changing city of Glasgow and outlines the way that the Open Museum works: how it builds relationships, creates opportunities and engages in a two-way learning process between individuals, communities and the museums' institution.

Each of the twenty story chapters begin with an object from the collections which spans time, cultures, trends, ideas and conflicts. A catalyst for the sharing of ideas, memories, stories, laughter and opinions – for engaging in creative processes and taking on personal challenges and for engaging with local and global issues. It charts the journeys and meanings given to objects in the hands of the people of Glasgow. Interspersed are insights into our resources, our reminiscence kits, travelling exhibitions, objects that have been accessioned into our collection and permanent exhibition spaces and objects that we have collected along the way.

The book celebrates human potential, charting the growing self-confidence as people's life experiences are given value. It reveals how they engage with other points of view and new ideas, make decisions, surprise themselves with their achievements and feel welcome in new spaces, sharing with their friends and family. Each object creates a ripple and makes a difference – imagine 200 objects, 2,000?

Out There situates the practice of the Open Museum in a wider interdisciplinary critical context around creativity, health and well-being, place, identity and representation. The stories are put into context through introductions which have been written by professionals in relevant fields. It is a creative collage

– written by the Open Museum team, current and past members, with input from community collaborative partners and participants and colleagues from other museum departments.

Dip into this book at any place – it is not meant to be read from cover to cover. Like a visit to the publicly accessible museums' store (Glasgow Museums Resource Centre, or GMRC), go with things that attract your attention. Let them inspire you to get started, develop an idea, in a way appropriate to the context in which you find yourself.

Out There acknowledges the Open Museum's own history and roots – the vision, context and challenges of the early days and its influences on museums in Glasgow, the UK and beyond. This is described by key people involved in its development from its inception. There are many other stories which could have been told. The bibliography references different aspects of the Open Museum's work which have been included in the work of other authors.

After twenty years, the Open Museum is still an experiment, still pushing boundaries and asking critical questions. The contemporary socio-political economic climate gives us the chance to be ambitious in re-imagining the role of museum and collection – as spaces and catalysts to inspire creativity, learning, dialogue and empowerment with soul and social responsibility.

We welcome your feedback and thoughts.

THE CITY OF GLASGOW AND GLASGOW MUSEUMS

Janice Lane
Learning & Access Manager
Glasgow Museums / Glasgow Life

Glasgow is a city that has seen many changes throughout its history. It has reinvented itself in response to its economic successes and also through necessity. It is currently the UK's fourth largest city (after London, Birmingham and Leeds) and Scotland's largest. Home to the biggest number of dispersed asylum seekers in the UK, it has long been the most ethnically diverse city in Scotland. It is still a city of change, of opportunity, innovation and conversely of entrenched hardship and poverty. Glasgow has some of the worst statistics for worklessness, addiction and poor health in Europe – and these statistics are daily realities for thousands of its citizens.

Over the last twenty years Glasgow has been undergoing a major change in identity, transforming itself from an industrial city struggling to stay alive in a declining manufacturing economy, to a city building a new identity from different economic bases, bolstered by culture, creativity and innovation. It was nominated as European City of Culture in 1990, won the UK City of Architecture and Design in 1999 and will be hosting the 2014 Commonwealth Games.

Understanding Glasgow's history is important in understanding the part museums and culture play in supporting this amazing city and the people that call this 'dear green place' their home. The work of Glasgow Museums is illustrative of how museums contribute to a person's identity, sense of well-being and sense of place – and in turn project the vitality and pride of the city, in a way that allows it to better understand the citizens who create its personality, history and future.

Glasgow Museums have a long established commitment to engaging with the city's diverse audiences. All our museums are free to visit and most are open seven days a week.

In many ways Glasgow Museums is a unique organization, being the largest civic museum

service in the UK, with ten museums and galleries. These include the Gallery of Modern Art (GoMA) a contemporary art gallery in the heart of the city; St Mungo Museum of Religious Life and Art, one of only four museums of religion in the world; a publicly accessible store, the Glasgow Museums Resource Centre (GMRC), which houses 80% of the collections not on display; the internationally known Burrell Collection, and Glasgow Museums' flagship, Kelvingrove Art Gallery and Museum.

The collection is as eclectic as it is large, with 1.4 million items. These range from world class collections of fine art to one of the best arms and armour collections in Europe, to natural history, social history, costumes and textiles, transport and technology and world cultures. Over 60% of the collection is of national or international significance, according to the Scottish National Audit, and we receive over three million visits per year. Kelvingrove is the most visited museum in the UK outside London and was recently named by *The Art Newspaper* as the twenty-seventh most visited museum in the world.

At the heart of Glasgow Museums is a fundamental philosophical commitment to the museum as a civic space, one that facilitates discussion around current and historical issues, beliefs and cultures; a 'safe' space for perceptions, ideas, stories and issues to be presented; where awareness is raised and a clear invitation given out to visitors and participants to contribute to and shape the discussion being stimulated by what is on display.

The Open Museum (OM) augments this commitment to the museum as civic space by challenging and dismantling the very essence of what that space is or should be. By taking the museum collections outside the museum walls we create new civic spaces and new opportunities for engagement, exploration and discussion.

Since its inception in 1990, the OM has taken the museum service out to groups and individuals who may not normally use museums. The methodology and tools it used in order to achieve this have developed and changed.

Changes in practice have come from reflecting on successes and challenges but also in response to the changing organizational context it operates within. Over the last twenty years there have been many changes (as with any public service), with the last major organizational alterations occurring as a result of the museums' *Best Value Review* in 2001. This resulted in a major re-structure of Glasgow Museums and the establishment of the Learning & Access department, alongside Visitor Services and Collections Services. Learning & Access extended our commitment and capability to create engaged and accessible museums. For the first time in its history, the OM became part of a larger team of staff dedicated to accessibility and engagement. This prompted a major review of its working practice and its approach to outreach working and delivery and a strategic approach to long-term partnership with key community service agencies to deliver shared outcomes.

The 2003 opening of GMRC, our publicly accessible stores, has also had a positive effect. The OM now has better physical and intellectual access to more of our collections. This in turn opens up new ways of working both within and outside museum walls.

At the heart of the OM are people and collections – the experiences that are revealed through their relationship and interaction with us is its legacy. We look forward to the next twenty years.

THE OPEN MUSEUM

Chris Jamieson
Open Museum Manager
Glasgow Museums / Glasgow Life

'One of the things I loved about working in the Open Museum was the fact when we were facilitating the handling sessions, the objects seemed to be freed. No gathering dust on shelves or sitting trapped behind glass – people got to actually handle the objects. I did occasionally feel like the member of a Liberation Front rather than a museum worker!'

Ewan McPherson, former Open Museum Outreach Assistant

The Open Museum has expanded the possibilities of what a museum is and can be. It extends Glasgow Museums' collections of international significance out of boxes, off shelves, beyond the walls of stores and museum venues.

Our work takes place in spaces where people who cannot or do not visit museum venues meet and gather – community centres, care homes, health centres, hospitals, shopping centres, festivals and prisons. Hosting us within their spaces, it is about relationships rather than audiences – it shifts the power balance from that which exists in a traditional museum venue.

Building relationships, trust and respect with vulnerable people takes time. We work with an open model so that any given project comes about through dialogue and negotiation. It is reviewed and adapted as we go along, and open and flexible to changes in direction.

The OM team is made up of curators, outreach assistants, a technical team and a manager. We are facilitators, creative practitioners and designers, experimenting with a range of participatory, inclusive ways of working to engage people with objects, designing and building community-led exhibitions to the highest professional standard. The team brings a wide range of professional experience, people and practical skills, knowledge and interests from community, creative and museum fields, which enriches the possibilities of what we can offer to community relationships.

Our very popular loan service enables people to borrow museum objects to support their own community-based work, which enables us to reach many more people than would otherwise be possible. We actively respond to invitations to bring resources to community-led programmes and festivals, allowing the collections to support local creativity, innovation and learning. We aim to

empower individuals and organizations to feel able to use the collections themselves.

Active collaboration with practitioners in the fields of mental health, literacy, social work, youth work, the prison service, housing and regeneration enables the collections to support Glasgow's social objectives. A final presentation of the work is also key – giving people the opportunity to stand back and reflect on what they have achieved and to share it with family and friends. This opens the door to different cultural venues across the city – for instance, a film that may be shown in a city cinema, creative writing read at the city literature festival, an exhibition shown in a community gallery or a museum space. In this way we democratize the sense of ownership (and thus enjoyment) of the collections, of museums and other cultural spaces and city festivals.

We also work with communities to create exhibitions for travelling around the city and for permanent community spaces for the enjoyment and engagement of their visitors. People bring their own imagination, stories and meaning to the objects they select from GMRC. They can get behind the scenes to find out about museum processes with conservation, design and technical staff. The exhibitions are designed and built by our technical team who carefully balance group choices with responsible care of the collections. Whatever the scale, the important thing is that the people involved feel ownership of the exhibition.

The OM is sometimes described as working on the margins, but what does this mean? We are passionate about what we do and have an extraordinary commitment and resourcefulness to making things happen. Engaging with people and building relationships is a two-way process – you give something of yourself so in that sense you are negotiating both personal and professional boundaries. You need personal and organizational support in practice, not just on paper.

The OM skilfully navigates through the museums' structure to get things done. The spontaneity of our work – having an open agenda and participants directing the programme – means we cannot determine in advance what our needs from other colleagues in the service may be. Outside of capital projects, international loans, and major exhibitions, our human resource needs do not match those given priority. We often act autonomously but also gather support, advocating our work amongst our museum colleagues and in the wider world.

While we put foremost our community engaged work we also take seriously a responsibility to influence the power bases in museums to bring about institutional change – to ensure that the core museum agenda is affected by the opportunity for dialogue with its communities. Documenting processes and annotating object records, in an effort to acknowledge the public contribution to the knowledge and meaning of our collections, is an important part of our responsibilities. We are currently actively engaged in influencing contemporary collecting, research and future exhibitions in museum venues so we make sure these reflect and are representative of the diverse communities and multiple identities of the people they serve.

CREATIVITY:

Celebrating the universal
nature of spirit

As a name and as an expression, 'Open Museum' is such a refreshing term. Museums hold a rich record of social history but still face the challenge of attracting the public to access their resources. Perhaps this is because museums are often perceived as exclusive places for the art connoisseur or history buff. The outreach work of the OM, in partnership with other organizations, groups, artists and members of the general public, is vital in promoting museums as public spaces.

In Glasgow, the civic museums are spaced widely throughout the city and they are all different. The OM bridges that gap by bringing the museum to the people. In my involvement with the museum as an artist I continue to see the value of creativity in developing this open approach. The five projects presented here are examples of the vital role that creativity plays in developing the relationship between museums and the community, in addition to nurturing relationships *within* the community.

My understanding of creativity is rooted in personal experience. Known by the ancestral name Moyo Chirandu Ganyamatope, my family have passed down a rich heritage through oral tradition. We respect spirit, as the essence shared by all of nature. At gatherings, creativity is expressed through the spoken word of poetry and storytelling, music, craft making, cooking and attire. By bringing people together and by placing value on everyone's contribution, creativity finds its significance in celebrating the universal nature of spirit.

In the traditions of my family every gathering takes place in a circle formation. In addition to the literal definition, the circle has five different names depending on the activity that is taking place – a meal, relaxing, mbira music, spoken word and addressing disputes are all different settings that celebrate the circle. The relevance is in the contribution that each individual makes to the circle for all to appreciate.

Through these museum projects, people have come together in a similar way.

We can all generate and develop ideas, but creativity needs to be nurtured through expression. Growing up in an open and encouraging social environment, I experienced the healthy nurturing of creativity without really being aware of how much this was helping my confidence at the time. Bringing museum objects into the community for handling purposes frees the objects from the restrictions of the 'do not touch' label. In turn, the project participants bring their own individual input to the circle. This creates an atmosphere that offers interpretation opportunities, sometimes as varied as the objects themselves.

Objects can inspire our imaginations further, as they change hands. Whether ownership comes about by mutual feeling or by unjust means, the object still retains its creative value. Objects are catalysts, instigating and facilitating powerful reactions, sparking discussion and debate. The forum created by museums gives people a chance to express their opinions and also to appreciate opposing viewpoints, reflecting the museum's role as a vehicle for social interaction.

That objects have the power to fire imagination is demonstrated here in the animation project devised by Aberlour's youth group. Using a piece of sixteenth-century leg armour, the young people who took part had the opportunity to bring history to life through animation – making it relevant to the present, and therefore to the group. In the case of the LUV project, this sense of pride reflected the wider appreciation of a city – Glasgow, in this case. This is creativity helping to add to the pride of a place and richness it carries.

When we look at an object from a past era, we cannot help being struck by the power that the passage of time has in terms of adding value even to ordinary objects. Physical materials are susceptible to

the damaging effects of time and so they need to be preserved. Memories, unlike physical objects, can be carried anywhere and everywhere, but like physical objects they can also deteriorate in quality and integrity with time. Using household objects from a past era brought many memories to participants of the 'Wellhouse Women' project, using museum objects to inspire people to show and develop their design skills.

My ancestors appreciated music as a spiritual way of communicating with the earth, the source of the materials they used to make their instruments. Today, our physical and social environment continues to go through its own changes, influenced by current socio-economic and political factors. The displacement of people through war and unrest has seen Glasgow become a new home for many. Located in a social space, the 'Lifecycle' project is the work of a partnership between asylum seekers, refugees and local women, ambassadors for Scotland meeting ambassadors of other nations in a housing scheme version of the United Nations.

An integral part of my upbringing was the great oral tradition of storytelling. I was always amazed by the richness of the proverbs, songs and poetry in recording the culture and traditions of my ancestors from past to present. This experience of the spoken word has helped me in my later life to re-analyze the commonly held notion that Africa, with no written records, is at a disadvantage to other civilizations. Preservation of a culture, history or people can just as effectively be stored in seemingly simple mediums. The storytelling project that features here is testimony to the lasting power of sharing stories. The oral interpretations breathe life into the objects while weaving a common thread between people of various backgrounds.

When strangers meet often they ask each other 'What do you do?' and also ask 'How do you do?' It is the latter question that I think seeks more of a spiritual connection, and relates to creativity. Creativity nurtures confidence, makes people feel valued, and adds to their social well-being, thereby improving their quality of life. The power of creativity to inspire and evoke the human mind is invaluable in recording life experience. A variety of social groups are represented in these projects – people of different ages, genders and nationalities – the stories of people's efforts and their experiences, and the connections that we can all make. Working with our hands has been identified by scientists as the feature that separates humans from other creatures. It is a celebration of life when the hands create from the heart.

Tawona Sitholé
Poet, musician and co-founder of Seeds of Thought

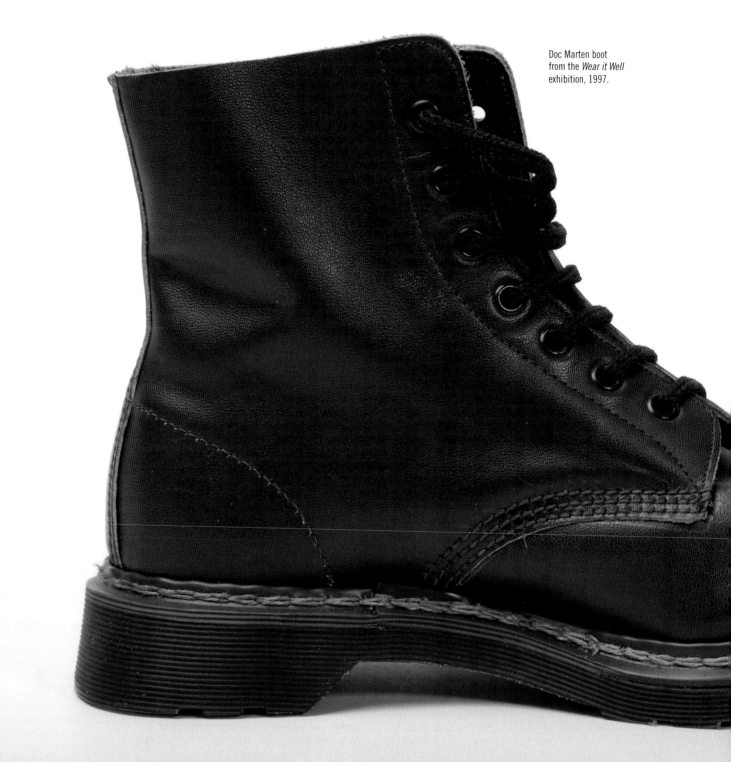

Doc Marten boot
from the *Wear it Well*
exhibition, 1997.

Participants:
Wellhouse Women
Number of participants:
100–150
Location:
Easterhouse
Duration:
1996/97

The very first Open Museum (OM) travelling exhibition *Wear it Well* was created by the Wellhouse Women, a self-directed art group in Easterhouse, in the east of the city. Working with the OM's curator Brian McGeoch they selected objects, including a maternity corset, a pair of Chinese silk shoes, a velvet collar and a brass collar from the Democratic Republic of Congo, alongside a pair of Doc Marten boots and a mini skirt, in order to explore the politics of dress. The exhibition started touring at the end of 1990.

The Museums Service had no permanent arts facility or museum at the time in the greater Easterhouse area, which is ten kilometres from the city centre. An area of high unemployment and limited recreational facilities, local people's innovation saw them organize themselves into voluntary groups to pursue their interests – the Wellhouse Women's art group is a good example of this self-sufficiency. In developing partnerships with such self-directed groups, the OM created access to museums for communities across the city.

Below: the *Wear it Well* exhibition, 1997.

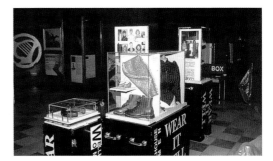

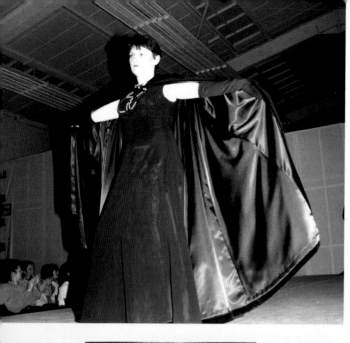

The success of this project led the OM to approach the Wellhouse Women again, when the opportunity arose to develop an outreach project to accompany the Charles Rennie Mackintosh (CRM)[1] retrospective exhibition, which took place in a major city centre gallery space in 1996. The idea of the project was to create a range of clothes inspired by his designs to be launched on the catwalk in style.

The Wellhouse Women included cutters and machinists from the clothing trade, who brought important skills necessary for the project. Other women in the group had clear ideas of designs and were keen to learn the skills to enable them to achieve their ideas. They all saw it as a way to increase the numbers of women in the group and have fun.

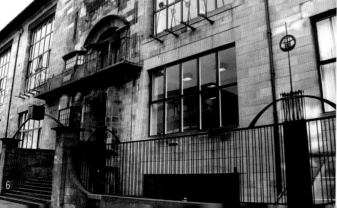

Above, left: Elaine from Wellhouse Women looking elegant on the runway at John Wheatley College.

Above, middle: writing desk from the Hill House, Helensburgh. Designed by Charles Rennie Mackintosh, 1904. Made by Alex Martin, 1905. Ebonized mahogany, mother-of-pearl, ivory, ceramic, leaded glass and metal. Bought jointly by the National Trust for Scotland and with assistance from the Heritage Lottery Fund and The Art Fund. E.2002.3

Left: The Glasgow School of Art, designed by Charles Rennie Mackintosh.

[1] **Charles Rennie Mackintosh (1868–1928) was a Glaswegian artist, architect and designer, famed for his organically inspired buildings, furniture and art.**

Mackintosh designs embellish the tourist landscape of Glasgow but many people who live in the city have not crossed his path. To get to know his work and to get to know each other better the group made a visit to The Glasgow School of Art, one of Glasgow's most famous buildings, which was designed by Mackintosh in 1896. They were also inspired by Glasgow Museums' sumptuous and internationally significant collection of Mackintosh furniture.

The women started drawing, designing, cutting, stitching…what was it like as a curator to work on a collaborative community project?

'…the flexibility required in a project like this is a liberating experience for the curator because it means allowing control of and responsibility for the project to be shared.'

Alex Robertson, Open Museum Curator

The idea and enthusiasm for the project was infectious. Its success was made possible by the interest and skills brought by the people gathered along the way. Fashion and design students from North Glasgow College took up project placements. Furniture made by students on a Mackintosh furniture making course at Anniesland College became props for the show. John Wheatley College built the catwalk and scenery flats, provided photography services, hair and makeup services and funded an art tutor to work with the women.

Above left: many hours of careful sewing were required to produce the garments for this project, which won the Gulbenkian Award for the Most Valuable Community Work for the Open Museum in 1997.

Above right: panel from a lampshade for the drawing room of the Hill House, Helensburgh. Designed by Charles Rennie Mackintosh, 1905. Embroidered by Miss Campbell, 1905. White silk with silk appliqué, decorated with silk braid, silk ribbons and glass beads. Given by Miss May Newbery Sturrock, 1953. E.1953.94

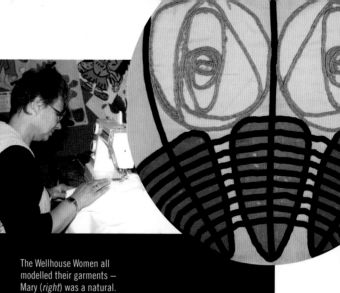

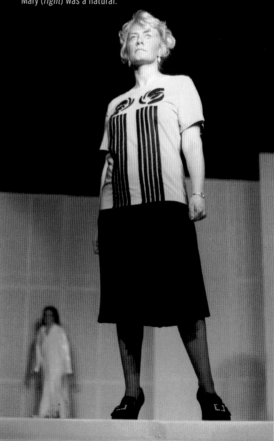

The Wellhouse Women all modelled their garments — Mary (*right*) was a natural.

Top tips for organizing a fashion show were given by David Mullane of Scottish Design and choreography for the fashion show was developed by Danny Dobbie from Visual Statement, a local dance project. Andy McPhail of the Greater Easterhouse Initiative – the local economic regeneration organization – took control of publicity.

Celebrities including interior designer John Amabile and actors Dorothy Paul and Katie Murphy modelled alongside members of the community, museum staff and students. The OM's administrator Irene Pyle and other staff and guides helped out as dressers and wardrobe mistresses. The partnership grew over ten months to produce 150 outfits, two lively events, and a video and exhibition.

Local people of all ages and sizes modelled a wide range of garments from T-shirts to kimonos. A full home audience of 350 brought the house down. No less flattering was the request from the Lady Provost for an outfit for her forthcoming Canadian trip to sell Glasgow abroad. Fashion show tickets enabled the Easterhouse community free access to the Mackintosh exhibition in the city centre and Glasgow Museums learnt much about organizing public events.

The project had a collective sense of fun but what else did it achieve? People discovered new skills and learnt as much about themselves as about Mackintosh. It was clear participants were eager to use their new found confidence to improve their self-worth and life experience. How did they achieve this? Some women went on to further education at John Wheatley College – students working on the video project enjoyed employment opportunities.

For those not wanting to return to education there was no easy answer. Some would have further opportunities for participation with the museums and other art agencies. It highlighted how important it was that resources were found to enable the community to build on its greatest asset – its people – in a sustainable way and for the arts to play an active role.

The OM built on its relationship with John Wheatley College. In 2000, the Trondra local history group, which grew out of a class at John Wheatley College, approached the OM to support them working on an exhibition about their local history.

Opposite: Wellhouse Women Elaine and Marie make light work of the difficult task of dressing a dummy for a photograph.

[2] **Platform is linked to John Wheatley College.**

Twenty years later Greater Easterhouse now has Platform[2], a fantastic arts centre, as well as a library and pool complex, managed by Glasgow East Arts Company. It creates opportunities for people to participate in workshops across art forms and brings the highest quality performances in theatre, dance and music to Easterhouse. The OM held an exhibition in Platform during the summer of 2010 to inspire performance work.

Left: Glasgow Museums' staff volunteered their own time to contribute to this project. Here is then OM Curator Fiona Hayes, pretty in purple.

COMMENTS

For all the years I stayed in Glasgow I didn't know anything about Charles Rennie Mackintosh, now I know. While I'm out and about I notice his designs….I thought it helped to bring out the skills that I didn't use much like drawing, dressmaking, organization and communication skills.
Betty, Wellhouse Woman

The students benefited from the 'real life' experience of working in the community…All of the nine students involved either went on to complete their H.N.D. or to employment…
W McAllion, Photography tutor, John Wheatley College

Because we could talk to the women quite openly, it helped boost my confidence and I found the project more enjoyable.
Annu, Fashion and Design student, North Glasgow

Above: woman's quilted slipper, 1930s.
From the 'A Night Out (2)' reminiscence kit.
TEMP.23090.1

Participants:
LUV Project, LUV's
Thursday Art Group
Number of participants:
c. **10–15**
Location:
Linthouse
Duration:
Summer 2007– ongoing

Handbags and shoes, potato mashers, trivets and OXO cube tins, all from Glasgow Museums' social history collections, inspired this project. The women from the Linthouse Urban Village (LUV) art group were keen to explore the dual roles that women held in the 1950s and 1960s – when they were young themselves. They chose to focus on the often imposed roles of 'wife' and 'mother' and their own desire to go dancing or on a 'night out'.

The LUV art group meet in the LUV Gallery which is supported by Linthouse Housing Association Limited (LHA). The gallery, one of very few community galleries in the city, hosts exhibitions by Glasgow-based artists and offers art classes for local people. This space for social interaction and creative expression in a friendly, supportive atmosphere was an important part of the women's week. At the time of the project the group was supported by resident artist, Emma Bibby.

Below: brooch from the 'A Night Out (2)' reminiscence kit.

The OM had not worked in this area of the city before. Our impact was enhanced by working in partnership with LHA, a respected organization that has social and cultural regeneration at the heart of its work. LHA's aim 'to develop a sense of community, raise aspirations of local people and improve the physical look of the area through innovative housing development and wider action projects'[1] has seen it support the gallery, a community café, a creative shop-front initiative and a recycling social enterprise project. Engaging people in these initiatives improves self-confidence, enhancing their quality of life and having a positive effect on community spirit.

Reminiscence sessions around the objects from the collections brought back memories. Conversations continued while pencils captured the objects in drawings. Brightly coloured prints inspired by the objects were soon drying all around the room. These creative responses, interwoven with memories and personal connections, were celebrated in a book. The drawings were also transferred onto a blank calico dress that had been made from a tracing of an original 1950s pattern held in Glasgow Museums' collections. The challenge of making it was enjoyed by volunteers who work regularly with the textile conservator. A gorgeous product of art and reminiscence took shape.

The dress and book took pride of place in the exhibition *Luvin' Life*, alongside the museum objects that had provided the initial inspiration. *Luvin' Life* brought together the fruits of other projects that the OM had been involved with in the local community. Silk banners inspired by objects from the Chinese and Japanese collections had been created by a second art group at the LUV Gallery. *What's your Story?* revealed a storytelling and scrap-booking project on the theme of celebration which had taken place in the local library. It showed the potential of the creative use of objects in literacy work through partnership with community learning.

The opening of the exhibition was celebrated in style at the LUV Gallery in May 2007 as part of the Museums Galleries Scotland (MGS) Show Scotland Big Events weekend. Additional funding from MGS meant we were able to create a truly unique event. Local musicians generated an atmosphere which helped the proud participants celebrate their achievements, firmly placing their work in the heart of the community. The Japanese Matsuri cultural group in Glasgow joined us, offering the opportunity to try on kimonos and participate in a tea ceremony. The exhibition extended beyond the gallery with the 'LUV Trail' which encouraged people to discover mystery objects in the shop fronts, well-loved community venues and to look closer at local Govan landmarks.

Luvin' Life highlighted the role the collections can play in social and cultural regeneration through strategic partnership work. It brought our whole team together working on different projects in the same area, engaging the community in innovative ways and creating exhibitions in unexpected locations.

COMMENTS

'It was great to hear the conversations of the four volunteers as they worked on the dress; what they had been doing when they were young women as well as the comments on how the pattern could be translated into reality.'

Helen Hughes, Textile Conservator, Glasgow Museums

[1] www.linthouseha.com/about_us.php, 30 June 2010

'What I really liked about this project was that it wasn't just about the past life of the pattern but, that it gave the pattern a voice in the present. I think that museums are not just about objects but are also about how people respond to them and having a contemporary context makes it easier for people to connect with an object.'

Helen Hughes, Textile Conservator, Glasgow Museums

Above: dress with printed objects.
Far, left: Style 1950s dress pattern from Glasgow Museums' collection.
Left: drawing from sketchbook to be printed on to a dress.

Our relationship with LUV continues as opportunities arise that match our mutual benefit and aspirations. Feedback from *Luvin' Life* highlighted that the art groups were particularly keen to engage further with Glasgow Museums' art collection.

Left: the artists enjoying *Luvin' Life* – their art and memories.

Right: woman's gloves from the 'A Night Out (2)' reminiscence kit. TEMP.23091.1 and TEMP.23091.2.

Below: Opening night event, *Luvin' Life*, LUV Gallery, Linthouse, May 2007.

Joint projects since *Luvin' Life* include *Picture This*, which was facilitated by Frances McCourt, an OM outreach assistant. It brought together members of the LUV art group and another creative project in the city. They shared responses to artworks in the collection through their descriptions, thoughts and feelings captured in creative writing.

Personal Space is an exhibition developed for the new maternity wing of the Southern General Hospital. Artworks created by the LUV group were inspired by objects from the collection chosen to represent the theme of personal space. The LUV Gallery is very close to the hospital and *Personal Space* gave participants the opportunity to showcase their work.

In 2008 the LUV Gallery was the venue for *Off the Shelf*, an outreach project based in another part of the city for Glasgow International (Gi), a biennial festival of contemporary visual art. The OM worked with the North West Women's Centre to explore museum objects in private and public spaces, the theme of the festival. By introducing an outreach element to this high profile arts event, the women involved saw a different part of the city and the LUV Gallery was put on the international map.

The LUV project is in the process of putting plans together for the redevelopment and regeneration of the former Fairfield Farmhouse in Elder Park. The proposal is to bring various local social economy enterprises together in a creative working hub at the heart of the cultural and social regeneration of the area.

The OM is discussing the ways it can enable the museum collections to inspire and support the development of this space.

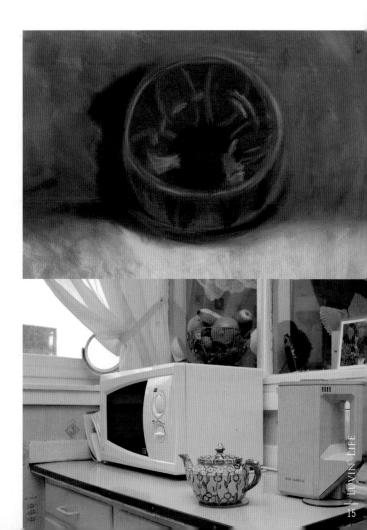

Right, top: pastel drawing from the *Personal Space* project, 2009.

Right: Jessie M King teapot, ceramic. E.1992.83.12a.
Teapot recontextualized in a participant's kitchen. *Off the Shelf,* exhibited at the LUV Gallery, Glasgow International, 2008.

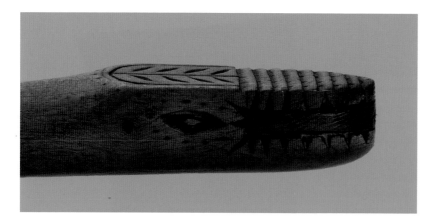

Dragon-headed toddy ladle (detail).

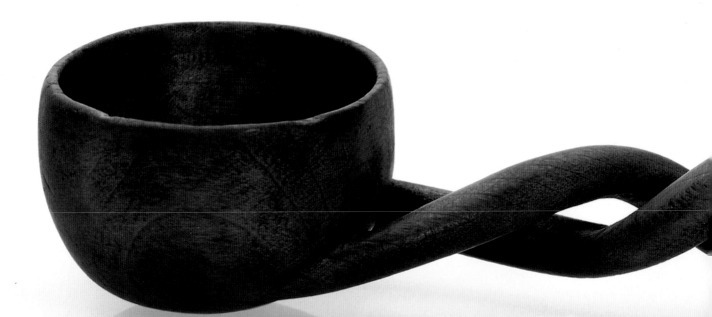

Dragon-headed toddy ladle'.
Wood. A.1938.11.cv

FACTS

Participants:
Glasgow Storytellers
Number of participants:
12
Location:
Glasgow Museums
Resource Centre
Duration:
November 2007
–January 2010

'The Storyteller's Luggage' – a collection of objects selected by the Glasgow Storytellers to inspire and encourage storytelling – includes something very unique. It is a dragon-headed toddy ladle, an ornately carved spoon that sits cool and smooth between your fingers. At one end is the rounded bowl of the ladle, while at the other are the engraved features of a dragon's head. Two strands of the wood curl and twist around one another to join the two. You think, 'it couldn't possibly have been carved – it must have been grown this way'. Your imagination sets to work – a story is bubbling.

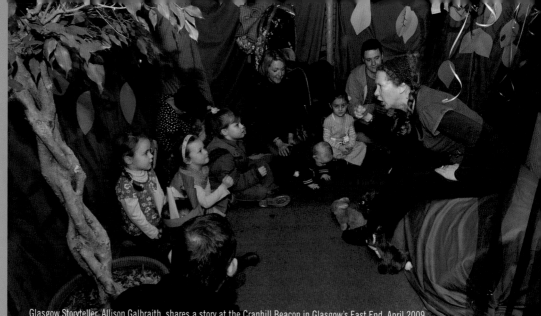

Glasgow Storyteller, Allison Galbraith, shares a story at the Cranhill Beacon in Glasgow's East End, April 2009.

Throughout its twenty years, the OM has worked in partnership with a number of diverse groups across Glasgow to develop object handling kits and travelling displays. Developed throughout 2008/09 in collaboration with the Glasgow Storytellers, 'The Storyteller's Luggage' is indicative of the fantastic potential that groups like the Glasgow Storytellers so often find amongst the collections of Glasgow Museums. A network of registered storytellers from across Glasgow and the surrounding area, members celebrate and promote storytelling as a contemporary art form through the sharing and passing on of their storytelling skills to people of all age groups and backgrounds.

Left:
'The Storyteller's Luggage' kit.

Recognizing an opportunity to further support their endeavour through the widely-used community loans service, the OM invited the Glasgow Storytellers to develop an object-based storytelling resource of their own.

Initial sessions and discussions with storytellers at GMRC focused largely on establishing who this resource was intended for, and how it could guide, encourage and support users in the sharing of their stories. We hoped that through the OM's community loans service 'The Storyteller's Luggage' could further bolster the network's efforts to stir and inspire the tradition of sharing stories throughout a mix of environments and amongst a range of audiences. Everyone realized that in each aspect of the kit's development – from object selection to accompanying materials – we had to work together to create a storytelling resource that appealed and could be approached by storytellers of all ability, skill and experience.[1] The Glasgow Storytellers showed a real

[1] **Not being storytellers ourselves, OM staff were well placed to measure and feedback to storytellers how accessible we found the resource over the course of its development.**

appreciation for the role of the kit's intended audience, and demonstrated great skill and consideration in their efforts to open up this resource and the objects within to make them as accessible as possible.

Great care was taken to find intriguing artefacts amongst Glasgow Museums' collections, while avoiding objects that might be so obscure as to inhibit users from making a personal connection with them. The idea was to invite stories at the most fundamental levels, for example a spoon, key, or bottle, rather than requiring users to have specific knowledge of each item's history in order to find their storytelling connection. We hoped that the wonderfully carved toddy ladle would draw the curiosity of users, but they were not expected to bring knowledge of the

object's historical significance, only to recognize it for what it is – a spoon.

Launched in January 2010 at the One Place Storytelling Workshop in Govanhill, storytellers, museum staff and community members came together to celebrate the arrival of 'The Storyteller's Luggage'. Stories were shared as members of the network were reunited with the objects they had discovered amongst our stores almost two years previously. We were delighted to find that despite some lulls in the development phase the strength of the fundamental connections that the storytellers had woven with the objects and the 'luggage' itself had endured.

Now available from the OM's community loans service, it is hoped that these objects, chosen by the Glasgow Storytellers, can continue to make similar connections with users across the city as audiences come together to share in their stories, memories and more.

Above: Glasgow Storytellers launch 'The Storyteller's Luggage', January 2010.
Right: ceramic ram's head. 7.K.1927.
Below, right: stories in the making – the luggage comes together in the OM workshop.

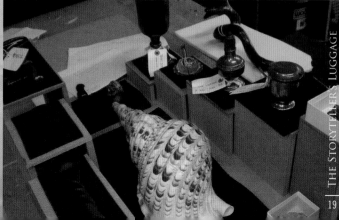

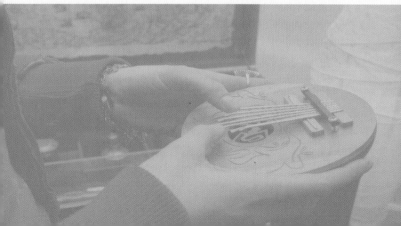

Throughout the project the OM worked to create as much room as possible for the voices and participation of storytellers, however a challenging balancing act arose during the physical build of the resource and the specialized process of preparing the museum artefacts for external loan. As committed custodians responsible for the care and preservation of Glasgow Museums' collections the OM can only share the responsibility of care for these objects so far, and in developing a handling resource such as 'The Storyteller's Luggage' the priority must always be for the safety of the objects. Could they be handled? How should they be transported? These are decisions that cannot be taken with partners like the Glasgow Storytellers, and the resulting restrictions on their input during these often lengthy, yet necessary, technical periods can unfortunately create pauses in involvement which might be damaging to some participants' sense of project ownership.

We attempted to bridge those breaks in involvement through regular updates whilst also turning the collaborative focus towards the development of accompanying materials, like storytelling exercises, and examples of object-inspired stories to further aid users in their interactions with the kit.

The efforts made and time taken by the Glasgow Storytellers to support the development of the project has meant that it is a resource that holds their welcoming philosophy close to its heart. Their 'blank canvas' approach invited us to look back and celebrate the immediate connection we all make with objects, even before learning of their great history and craft.

Now a year into its journey around the city, we are happy to report that contributing storytellers have continued to follow and support 'The Storyteller's Luggage' in its travels, helping others to share and rediscover stories of their own within the kit.

Below: initial sketches for 'The Storyteller's Luggage'.

Opposite: guiding the Luggage on its travels, this brass compass plate invites stories of journeys and adventure. TEMP.17436

COMMENTS

The luggage is magical – just opening it up and looking into that fantastic space – all the stories of the world are in there.

Jean Edmiston – Glasgow Storyteller

I think the lull did at times make participants wonder if the luggage would ever appear. However, having said that, they were definitely reassured at regular intervals that things were progressing, through email updates and OM visits to Glasgow Storyteller meetings…

Rachel Smillie – Glasgow Storyteller – One Place Storytelling Workshop Coordinator

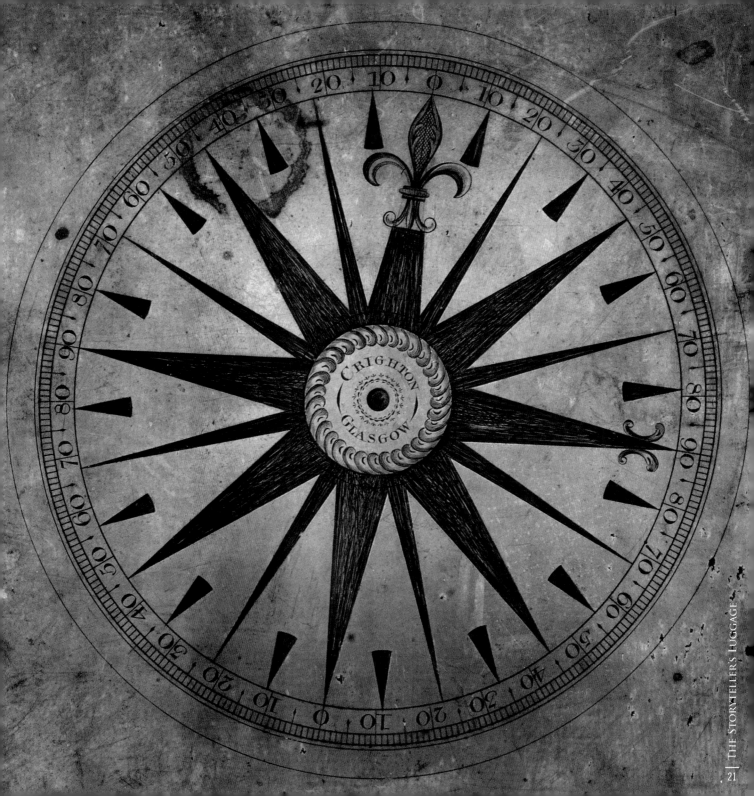

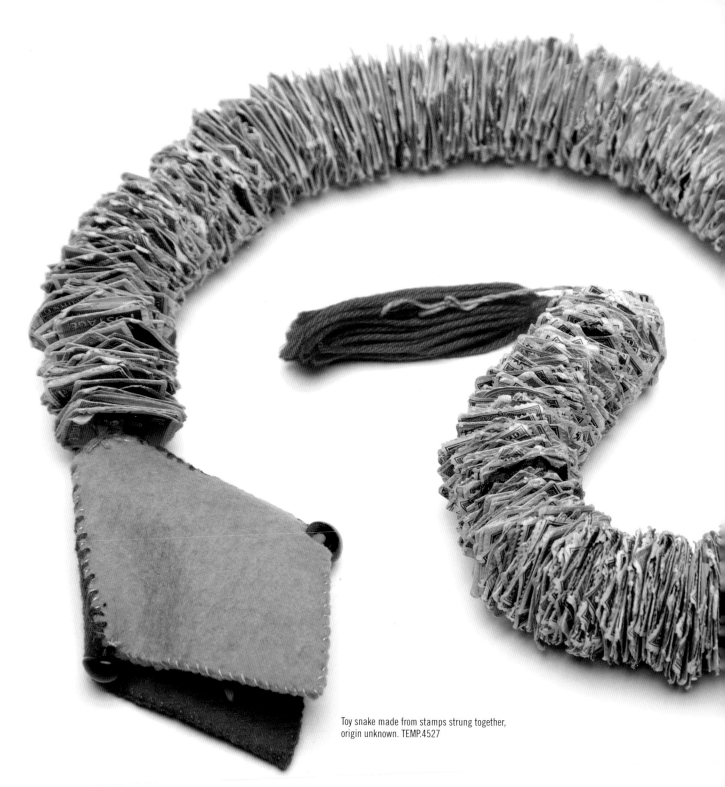

Toy snake made from stamps strung together,
origin unknown. TEMP.4527

FACTS

Participants:
**Kennishead Women's Group,
asylum seekers, refugees
and Glaswegians**
Number of participants:
8–20 members
Location:
**Flat in Kennishead
provided by Greater Pollok
Integration Network**
Duration:
August–October 2008

During research into recycled objects to inspire this project we came across a snake, lurking in the dark depths of the museums' stores.

This snake is older than he appears and is well travelled, so what better object could inspire a project about creating new life from old, celebrating and mixing different cultures and crafts? He captured our imagination.

All museum objects have 'lived' before they come into our collections but this one's story is clear for all to see – it is woven into his skin. Looking closely, the snake is made up of hundreds of stamps prised from long-awaited letters and treasured postcards from far-flung lands. Some of the countries represented by the stamps now no longer exist, so elements of the snake's story seemed to echo that of the displaced participants that made up the group.

The snake was chosen for Glasgow Museums' collections, not for its expensive material or because it had been made by a famous name but simply for its beauty and story. Social history objects are given the same value as 'high art' in museums. Every object offers an insight into a different culture, which is where its value lies.

Right: toy car made from drinks cans. South African. PROP.211.8

Just as the snake is made of tiny illustrations and symbols all linked together to create something new, the Kennishead Women's Group consists of locals, refugees and asylum seekers, who meet socially in a flat provided by the Kennishead Integration Network.

Kennishead is a small area in the south side of Glasgow, where the skyline is dominated by the high-rise flats in which the group live. The Integration Network is one of several that were set up in the city to support refugees and asylum seekers, promoting harmony and mutual respect in the diverse communities.

The women approached the OM as they wanted to broaden the range of their social activities. 'Lifecycle' took recycled objects from the collection as inspiration. Working with the group we used traditional skills to transform waste products into new artworks. It was designed to be a sustainable project – utilizing traditional craft skills and waste material, it could be continued by the group after the end of the 12 sessions.

The snake has been lovingly handmade and this was the inspiration for the craft activities. We used simple techniques like papier mâché, knitting, weaving and printing, to make new objects from old. Some of the women were already very skilled and were happy to help those with less experience.

As part of *Lifecycle* we accessioned five South African recycled objects to fill a gap in Glasgow Museums' World Cultures collection. Some of the women in the group are South African and were amused and pleased to find familiar objects in our care. They were able to share stories about these objects with the group.

The flat was the responsibility of various volunteers which created problems when taking museum objects out to them – it was difficult to arrange suitable times to drop off or pick up objects. It was also small and this proved difficult for some of the activities, like printmaking, because it limited the number of objects that could be taken to the group, as they had to be displayed away from any activities.

As it was a drop-in group the numbers of participants varied each week but there were usually around 15 women. A new activity was planned for each session so that newcomers could take part and the group could try different techniques. A number of the women would have been unable to attend without their children and so sometimes up to four young children were brought along. This made it more difficult for the group to focus and had not been anticipated.

By far the greatest difficulty faced was that some members of the group were detained and deported throughout the project. Often the women would hear news of their friends for the first time at their meetings and this was, understandably, very distressing. On the first occasion, we discussed with the group coordinator whether she would like to continue the session. She felt that it was important for the participants to have activities to focus on.

The women made many beautiful artworks and learned a variety of new skills. Those who were accomplished knitters and weavers already were happy to share their knowledge with other members of the group and their mutual support and resilience was inspirational. A display of their resulting work, alongside the objects which inspired them, was exhibited at the Burrell Collection. This gave it the value it deserved, sitting alongside 'high art' in a gallery. On reflection, the snake is more significant now than at the time of the project – his fabric links the colours and pictures from different cultures just as the group celebrated and brought together women from various backgrounds. He was made simply from found objects, as were our artworks, and he was collected by Glasgow Museums because he was deemed to be precious and worth preserving.

Clockwise from the top: bag made from wire and bottle tops. South African.

Cow mask made from old packaging. South African. SP.2008.33.3

Bowl woven from plastic bags, Kennishead Women's Group.

Woven telephone wire bowl. South African. SP.2008.33.4

Cultural traditions adapt, they don't die. In traditional African craft, beads took over from seeds, grasses and wood and the use of recycled waste is just another adaptation to the materials at hand, the objects illustrate great resourcefulness and adaptability.

Pat Allan, Curator of World Cultures, Glasgow Museums

COMMENTS

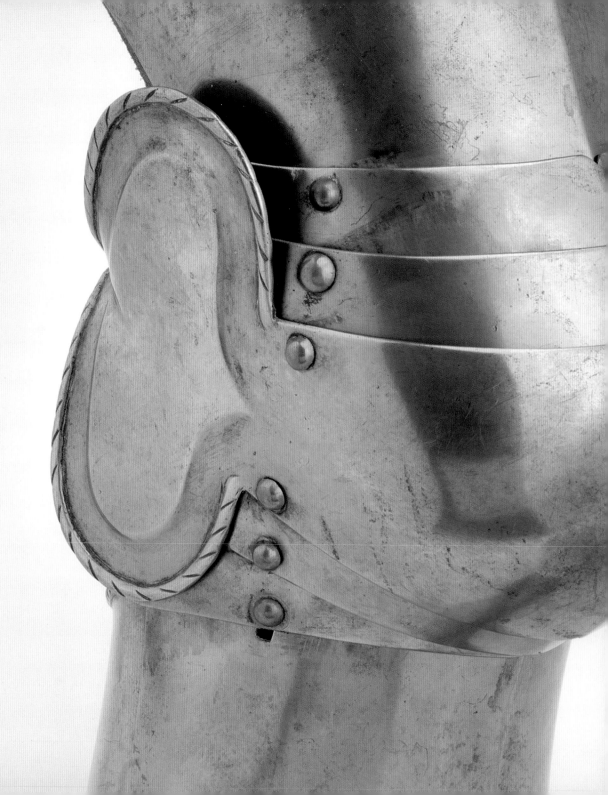

Leg defence (detail)
– one of a pair,
from the RL Scott
Collection of arms,
weapons and books.
E.1939.65.u.[7]

THE LIFE IN OBJECTS

Catherine Laing

FACTS

Participants:
Young people aged 11–16 years from Kennishead flats who attend a youth group run by Aberlour Children's Charity

Number of participants:
4–8

Location:
Kennishead Community Hall, Kelvingrove, Glasgow Museums Resource Centre, BBC Scotland studios, Glasgow Film Theatre

Duration:
August 2009–ongoing

If this leg of armour could talk, it would tell many tales. Some of these stories we can discover just by examining the steel body. It tells of clever design and manufacture – an armourer carefully cutting and shaping many small parts, skilfully riveting them together to create a flexible leg defence. Other tales require a little knowledge mixed with a good dose of imagination – sixteenth-century knights riding horses, battling and dancing.

While these narratives could belong to any one of hundreds of pieces of armour in Glasgow Museums' collections, this piece has a different story to tell. It was brought to life using animation by a group of young people from Kennishead. They breathed new life into it with inspiring ideas of Robocop, knights on horses and Michael Jackson dancing. With these young people, the armour travelled to Kennishead Community Hall (KCH), Glasgow Film Theatre (GFT) and the BBC studios. The young people asked the leg armour many questions – 'What would it be like to wear?', 'Where would we go?', 'How would we move?' and because the young people listened carefully they discovered the answers. They made the armour the star of its own animated film, *A Tribute*, and an accompanying documentary. As stories go, it is a good yarn. We hope it inspires many more.

Left: young people from Kennishead at GMRC, October 2008.

'...the whole process
of the animation was
really brilliant for the
young people and
for us...'

Nicola Ferguson (Aberlour youth worker)

Most Thursday nights young people living in Kennishead flats come together at a drop-in youth club run by Aberlour – Scotland's Children's Charity. They meet in the community hall that nestles at the foot of five high-rise flats in Kennishead, an area in the south-west of the city – it was here we first met them.

'The Life in Objects' endeavours to bring together groups of young people from across Glasgow to celebrate and share their diverse interests and experiences through museum objects and animation. The young people from Kennishead were the first.

The OED defines animation as, 'the state of being full of life or vigour; liveliness'. When we bring objects out of the museums' stores and into the hands of communities, the resulting vigour and liveliness is quite special. By enabling young people to explore museum objects through animation, we help them express this sense of life and fun.

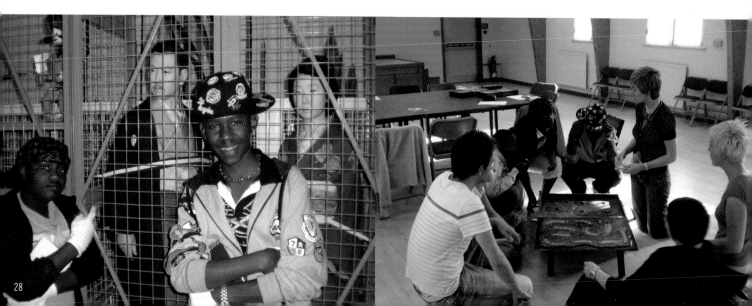

To ensure the participants were fully engaged with the project, it was essential that their ideas and passions drove all aspects of the work. Aberlour's youth workers worked alongside the OM to achieve this – their participation, hard work and passion encouraging a similar attitude in the young people.

Early on it was clear the young people had a love of dance and performance. From pretending to be archaeologists with magnifying glasses when we first met them at KCH, to break dancing on the lawn of Kelvingrove, we hoped to channel this enthusiasm into the animation. On a tour of GMRC we made full use of their theatrical flair, through role play complete with lab coats, magnifying glasses and silly hats. Everyone then voted – as the Animation Project's Collections Committee – for their favourite object, using presentations, ballot papers and a ballot box.

The chosen leg armour travelled to KCH, where the young people explored it in great detail. Over several sessions they brought it to life – imagining where the armour had been, what it might feel like to wear and how it might sound, using a wide range of AV equipment, art and junk materials.

'I had to act like I was wearing the armour… and then I had to act like I was on my horse or walking. It was kinda tough wearing the armour.'

Plemadi (young person from Kennishead, on creative sessions)

Above: looking for inspiration at Kelvingrove Art Gallery and Museum.

Opposite, above: Kennishead flats, south-west Glasgow.

Opposite, below left: the group visit the GMRC stores.

Opposite, below right: getting to know the group at Kennishead Community Hall, August 2009.

Left: leg armour from the RL Scott Collection of arms, weapons and books. E.1939.65.u.[7]

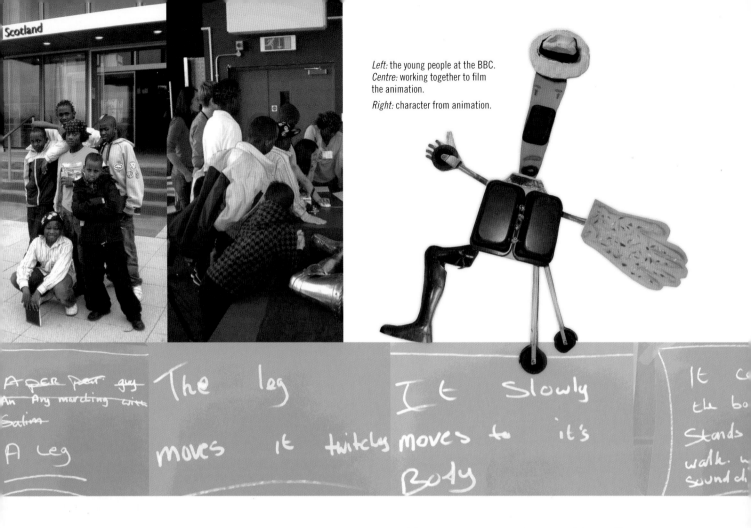

Left: the young people at the BBC.
Centre: working together to film the animation.

Right: character from animation.

These ideas inspired stories told through visual storyboards and audio storytelling. All the different narratives were woven together to form the plot for the animation incorporating the leg armour, dancing and Michael Jackson. The group worked together to make disco balls, clubbers, dancing shoes and speakers to tell their tale.

The young people took the leg armour, their props and their ideas to BBC Scotland's Clydeside offices where they discovered the inner workings of the radio and television studios. Working together they used a camcorder and a PC to shoot their animation, taking over 500 photographs! With the help of the staff at the BBC they then edited this material, finally adding a soundtrack and giving their film a title – *A Tribute.*

Our relationship with BBC Scotland was slightly problematic in the run up to the group's session at their studios. Issues arose with copyright ownership, but these have now been successfully resolved so we can exhibit the young people's animation on Glasgow Museums' website and in venues across the city. We provided the group with AV equipment to record their thoughts and activities throughout sessions, interviewing each other and staff. This video diary

method proved popular, so by the end everyone was adept at using these tools. The resulting footage was edited into a short documentary illustrating all their hard work.

The young people celebrated their achievements with families, friends and the leg armour by screening their animation and the documentary at the GFT on 30 January 2010. It was fantastic for the young people to see their film (and themselves) on the silver screen, and the end credits were greeted with cheers, applause and the group taking a bow! The leg armour has now returned to GMRC, but the young people's success has inspired other youth organizations across the city to get involved in our project.

Over the next year more groups will bring different objects to life using animation, telling their stories and sharing many adventures.

Below: animation storyboard.
Below right: the group with the leg armour.

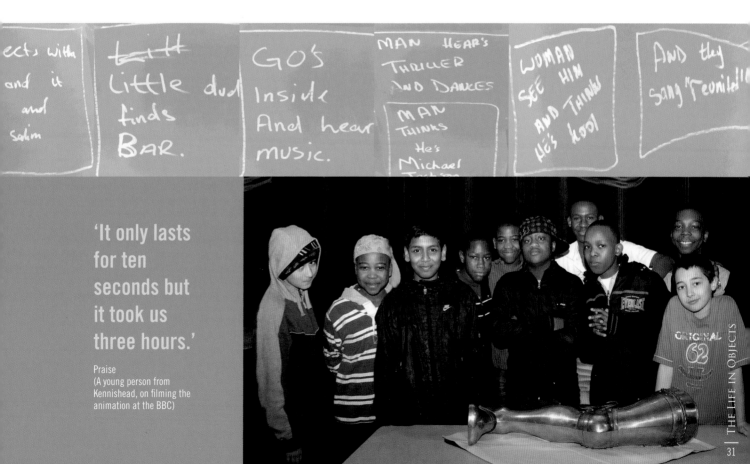

ects with and it and salim

t~~itt~~ Little dud finds BAR.

GO'S Inside And hear music.

MAN HEAR'S THRILLER AND DANCES
MAN THINKS He's Michael

WOMAN SEE HIM AND THINKS HE'S KOOl

AND they sang "reunite"

'It only lasts for ten seconds but it took us three hours.'

Praise
(A young person from Kennishead, on filming the animation at the BBC)

The Open Museum,

OBJECTS AND
WELL-BEING

The OM is based on the belief that opportunities to handle objects and host community-led exhibitions reveal the human dimension of objects in ways that significantly enrich people's lives. Most obviously this takes place in reminiscence sessions, but the OM also attends local festivals, gala days, and other events, so the direct personal connection is not necessary. Objects from overseas or from before living memory can serve as emissaries from those cultures with which people can connect through research and empathy and the experience of touching the real thing. For immigrants, a single object can evoke the culture they have left behind, and with it, the relationships they formed.

What reasons are there for thinking that these object experiences might make a difference to people's lives? There are many ways humans relate to and use objects, apart from their practical use, as, for example, tools, vessels, garments, weapons or means of recording and communicating information. One theory is that a primary symbolic use of objects is to demonstrate superior status, due to social origins, taste or wealth. Objects are very good for this purpose and people can distinguish infinitely small gradations.

Other theories emphasize the importance of objects in global consumerism. During the nineteenth century Western society changed from producing goods mostly in order to meet our needs and increasingly started consuming in order to produce – in the process creating many new 'needs'. This process, based on a vision of society made up of completely autonomous individuals, generated huge wealth (for some) and created our consumer culture. Advertizing and social pressure create the desire for an astonishing range of products, in a system where, by definition, the objects never really satisfy. We are constantly trained to 'need' more and more useless things. The grand buildings and giant hoards that make up museums suggest that they are, to a large degree, temples to status and luxury consumption. How does the OM fit with this view?

Another, more positive, theory about objects is that we use them to express and embody our closest relationships. This is most obvious in the case of photographs of our loved ones, the snaps of children we admire from the wallets and handbags of our friends, the friends and relatives now dead, and of places that matter to us – locations of memorable holidays, places where we previously lived which may have changed. Beyond representations however, objects bind us together as gifts, mementos or symbols of our deepest relationships, with people and places. One of the most evocative studies of this role of objects is by anthropologists Daniel Miller and Fiona Parrott in the book *The Comfort of Things*. They convinced 30 households in a London street to let them into their houses and to talk to them about their possessions. Only 23% of the people were from London – the others came from as far afield as Jamaica and Ireland, Brazil and Estonia. 'This was not a culture, a neighbourhood or a community'. But that does not mean that the people were isolated, suffering alienation in the global city. Instead Miller and Parrott found all sorts of connections – all of them expressed through objects. For example, the Clarke family hold Christmas in a way that could be considered the acme of consumerism, with so many decorations per square metre that they communicate 'marketing victim' rather than 'avid consumer.' But for Miller, the elaborate decorations are a means of cementing the relationships of a large extended family, every one of whose gifts is wrapped and placed under 'the most perfect Christmas tree.' The life stories Miller collected show how we use objects to bring 'order, balance and harmony' in our lives, so that, he argues 'the closer our relationships with objects, the closer our relationships with people'. His negative evidence comes in the form of George, whose flat is 'empty, completely empty, because its occupant had no independent capacity to place something decorative or ornamental

within it'. All his life he had lived in institutions with no sense of power or authority – he had never been able to 'take responsibility for anything, let alone the decoration of his own home'. The emptiness of his life was reflected in the 'chilling absence' of personalized objects.

One mechanism by which we acquire this close relationship with objects may be found in early childhood, as interpreted by the great English psychoanalyst, Donald Winnicott (1896–1971). Unusually, Winnicott's theories were not based on adult memories of childhood traumas but on working with, and liking, children. He watched how children relate to their first object – the soft toy or blanket which the child takes to bed and becomes especially attached – which he called the 'transitional object.' The transition is between being part of the mother and a more independent being. Play with the object allows the child to experience being 'alone' in the presence of the mother, to rehearse becoming a separate self. Winnicott argues that this experience of play with an object is the paradigm of later creative experience of the arts, culture and science. Through the objects we create – whether these be a painting, a play or a scientific theory, a room we decorate, or something purchased as a gift – we seek to shape the world according to our inner desires and fantasies, to reconcile wish and reality, to express our relationship with the world and especially with the people in it whom we care about.

Materialism and consumerism work by generating unsatisfiable desires for more and more objects. We are all affected by this to a degree and some people may be overwhelmed by it, but few are totally passive. We take mass-produced objects and invest them with meaning, to express our sense of who we are, and who we care for. Museum objects can provide an additional dimension, giving access to a rich array of things not easily available in the everyday world, whether because of their rarity, high monetary value, or simply because they have been made redundant by fashion and technological change. These objects can trigger memories (some fond, others painful), inspire appreciation and creativity or foster curiosity about human difference. They can re-connect people who have left their countries, willingly or under duress, with the culture they have lost. They can evoke a lost era for people who feel that, through the passage of time, their country has left them. Above all they can embody human connectedness, expressing the relationships which are part of our essence. The OM has sought over the years to release this human dimension through reminiscence sessions, where objects from the recent past or the original homes of migrants evoke lost times and places. But this direct personal connection is not necessary.

If objects are extensions of ourselves, embedded in our relationships, it is hardly surprising that recent research is showing that interaction with museum objects can improve health and well-being. Studies show that reminiscence sessions based on objects for elderly people support mental alertness and social engagement. Patients in hospital recover faster and maintain morale if they engage with museum objects, just as they do if the wards are well designed and if they have views of nature. This is less surprising if we see objects as extensions of ourselves, embedded in human relationships and not simply functional instruments, or indicators, or a lust for status or of consumerist addiction. People's own relationships with cherished objects and with each other can be enriched by contact with the myriad objects in museums. The OM's mission is to broker these links between people in the present and their fellow humans who have created the objects in the city collection, no matter the distance in space and time which separates them.

Mark O'Neill
Director of Policy, Research and Development,
Glasgow Life

During the pilot project phase of 1990–91, the OM team explored a range of ways to open up access to Glasgow Museums' 'reserve' collections to communities across the huge geographical area that was then covered by Strathclyde Regional Council. We wanted to find effective and meaningful ways to explore the potential of the collections outside the museums' walls.

One possibility identified early on was in supporting the burgeoning demand for handling objects for reminiscence as a leisure or therapeutic activity. By the late 1980s many social and health care professionals were recognizing the significance and benefits of reminiscence. Reminiscence is more than nostalgia about the past and is something people do at different stages throughout their life. It links an individual's memory with self-identity, and is seen as a means of fostering social interaction and as particularly beneficial when assisting people suffering from dementia, as their long-term memory tends to be stronger than their short-term memory.

Here was a role for many of the social history objects that sat in store, where they might have an impact apart from the educational or aesthetic. Although aware of the demand for material to use as memory 'triggers' I talked to people working in this area in Strathclyde about what sort of resources they needed. It was interesting to see that questions being asked within the museum world at the time about memory, identity and engagement with the past were also being explored in this field, particularly in developing means of reaching out to people. Clinical Psychologist Liz Renwick at the now closed Gartloch Hospital, Glasgow, and Senior Occupational Therapist Tricia Duncan at Ravenscraig Hospital, Greenock, both contributed in shaping the development of the early kits. They were very keen to get objects and photographs to handle that were relevant to the lives and experiences of their patients, as this could make a huge difference to their work.

The starting point for putting the kits together was looking at how we remember and the variety of sensory triggers that help us remember. There were objects to touch, selected from duplicate material in the museum collection, large encapsulated photographs, sometimes music to play and occasionally something to smell. The strong scent of carbolic soap in the 'Washday' kit was often enough to get people talking about the ritual of washday as the box was opened.

Each kit was developed to show different aspects of life in Glasgow throughout the late nineteenth and twentieth centuries. We also found that we needed to be aware of gender issues as most of the aging population was female and had grown up in an era where gender strongly defined someone's role in life. A failing, though, was that sometimes our enthusiasm for the type and quantity of material meant that some of the early boxes were heavy and bulky and stretched the concept of being easily portable. One early example demonstrated clearly the powerful, intangible connection that an object can forge. On returning the 'Washday' kit an Occupational Therapist (OT) excitedly told me what had happened in one of her sessions with the kit in a group coping with dementia. The participants included a woman who never communicated with the people around her. She seemed totally isolated although she was always included.

The OT handed round the objects and asked questions to encourage discussion. When it came to the goffering iron, one woman unexpectedly started talking, exclaiming what it was, how it was used and went onto to talk about how she ironed lace with these irons when she worked in a hospital laundry in the early years of the twentieth century. It really brought home the emotional impact of objects, particularly how once everyday mundane items seem to resonate through time. I had wondered whether to include this particular item as, even in 1991, it seemed likely to have moved out of the range of living memory.

'It was a fantastic opportunity to let the patients have access to the museum collections and a useful part of their treatment plan. It's been of huge benefit to everyone concerned to do something like this ...'

Janet Barclay, Occupational Therapy Department, Ayrshire Central Hospital, Irvine

Right: stand for the goffering iron that brought back so many memories and opened up a channel of communication.

This iron had helped the OT to communicate with the woman and foster some level of social interaction. The creative potential of the reminiscence kits was demonstrated by the 1992 touring exhibition, *Mirror on the Past*, developed with women in long stay wards at Ayrshire Central Hospital, Irvine.

The six women had all had strokes and the process of making the exhibition was part of their occupational therapy plan. Two art school graduates were employed to work with the women and OT staff. Starting with the reminiscence kits and drawing memories, the women went on to create memory boxes of artefacts, museum objects and quotes from their oral history interviews for this exhibition. The hospital staff attributed much of the women's recovery of their motor skills and increase in self-confidence to their involvement in this project.

Requests for the kits soon took on a life of their own as demand outstripped supply. In response we organized seminars to encourage good practice and provide an opportunity for the people using the boxes to exchange ideas and explore the creative potential of reminiscence. At one seminar, so many of the delegates were from Ayrshire that they started meeting together and created their own reminiscence boxes.

The response to the reminiscence kits really brought home how important our memories are to us in creating our sense of self and community identity. It showed that objects have an emotional meaning and value apart from the aesthetic and educational and can contribute towards our health and well-being.

Reminiscence Kit Resources

The OM currently has seventy reminiscence and handling kits in its loan service. These individually themed boxes contain around twenty objects, carefully selected from the collections for their suitability for handling. Following an induction the kits can be borrowed for a week at a time. These resources are enjoyed by around 22,000 people per year.

Through the loan service the OM enables around 132 organizations each year to use the collections independently. While they are predominantly used for reminiscence the kits inspire storytelling, creative writing and even dance performances. The kits reach many vulnerable people who would not otherwise be able to enjoy Glasgow's fabulous collections.

Above: objects from the 'World Religions' Buddhist object handling kit.

Right: the bird that never flew from the 'Glasgow Coat of Arms' reminiscence kit.

Below: the 'Enigma Three' object handling kit.

Below: the '1970s' reminiscence kit.

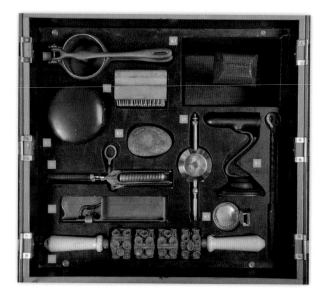

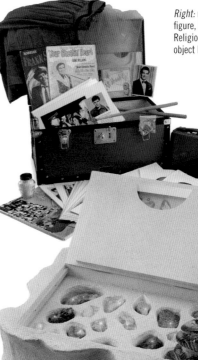

Left: the 'Football' reminiscence kit at Ruchazie Community Centre
Centre: the 'Crystals' object handling kit and the '1950s Music' kit.

Right: resin Buddha figure, from the 'World Religions' Buddhist object handling kit.

Calabash
rattle made from Gourd
seeds and cotton string.
Sierra Leone
A.1985.13.eo

Participants:
**Group of women participating
in MFS therapeutic group
work programme**
Number of participants:
10
Location:
Medical Foundation Scotland
Duration:
**September 2006–April 2007
workshops, design and build,
launch and evaluation**

Water Jug
I love working with clay because my husband worked in a factory
with clay. I want to make a huge 5 litre pot for the museum! Mary

Bench
In my language we call
remember my grandmu
it – so if we wanted fun
Mariama

FACTS

Y ema* made a swift move towards
the calabash rattle. Before I knew it
she had it in her hand and had burst
into a song about hens in a farmyard from
her childhood.

The spontaneity, the power of touch, the
sound of life given back to this object was very
powerful. Yema is a refugee from Sierra Leone
and had come to GMRC to see objects as part
of an inter-cultural, inter-generational storytelling
project. The rattle is part of the Massie-Taylor
collection sold to Glasgow Museums in 1985.
Julian Massie-Taylor was a teacher in Sierra
Leone in the 1950s and had collected the rattle
when he was living there. It has spent most of the
time since in a box in storage, silenced.

Yema's response and my previous experience
working with refugees and asylum seekers in
London and in post-conflict Guatemala made
me wonder if there were further opportunities for
the collections to support creative therapeutic
processes with refugees and asylum seekers
in Glasgow? Could new stories, connections,
dialogue and knowledge from refugees emerge
from the colonial shadows of the world culture
collection? I contacted the Medical Foundation
for the Care of Victims of Torture (MF), an
organization I had known in London, with
a recently opened centre in Glasgow, and
following an initial one-off exploratory session a
partnership with Medical Foundation Scotland
(MFS) began.

Opposite: Mary at the launch of *Shared Earth*, 2007.

The first project with MFS, 'Shared Earth' began with a group visit to the Burrell Collection, a unique collection of art from around the world, housed in the woodland setting of Pollok park. The women led the way to objects that caught their attention among the Egyptian stone and ceramic pieces, Chinese and Islamic ceramics and bronzes. Conversation started around things the objects reminded them of. A three-legged Chinese bronze piece recalled pots used for cooking, the space under the legs for firewood, the shapes of pots, the coolness of water, an alabaster piece the shape of grandmother's stool, and the green of the woods of the forest back home. We took photos for inspiration later in the project and experimented with different types of clay – the group's chosen medium – and made our first simple pots supported by Caroline Austin, a Learning Assistant at the Burrell. The visit also helped raise awareness of museums as calm, safe and free places for the women and their children.

The MFS space soon became a hive of activity. The women took inspiration from the Burrell photos and objects from the collection taken to MFS for handling and discussion. Working with the artist Maggie MacBean and Annie, an empathetic interpreter, the women worked with clay, shaping forms and making marks, timidly at first then getting bolder. They came to make things with their hands and hearts and share languages, laughter and stories from their lives.

Chia wine vessel, bronze
China, possibly 1st Phase. 8/120

Right: coconut shell, with incised geometric design, Guyana. 48.56.w

They chose colours and enjoyed the surprise of their objects emerging from the kiln.

They found the strength between appointments with doctors, lawyers, immigration officers and the fear of detention to move out of isolation, gaining confidence through expressing themselves, sharing their work with others. In physically making something we express something that may be more difficult to articulate in words. The process was a step in a journey towards healing, empowerment and taking control of their lives again. The clay brought out a determination to get things finished, with women going to extraordinary lengths to make sure their pieces were included in the final exhibition.

Shirley Gillan, the MFS manager, was actively involved in all sessions, keeping a notebook of observations, reflections and comments during the session or feedback time which was integral to each one. She was there at the end of the session for one-to-one support for individual women as appropriate. The artist and interpreter were part of discussions which enabled each session to build on reflections from the previous week. The women in the evaluation expressed how important it was to have the project based in MFS space, where they felt safe and understood. They also stated how crucial it was to have an interpreter, saying that while they could understand most things it really helped to have small details explained, to ask questions and to be able to express themselves.

COMMENTS

'I am going to make the jug on the photo – haven't managed it yet but will fight to the death to make it.'
Participant

'I used yellow, the colour of hope.'
Participant

Above: carved wooden hornbill. Papua New Guinea. ETHNN.1737

'It [wet clay] smells like my country after the rain.'
Participant

While the process of this project was very important, so too was the creation of the final exhibition, *Shared Earth*, which brought together the pieces the women had created alongside the museum objects that had inspired them. It involved the women in taking decisions about the display and describing their pieces in words, giving them the opportunity to stand back, reflect and celebrate their determination and creativity.

The group created their own invite to the opening of their exhibition for International Women's Day 2007, going on to call themselves the Amazons and continuing to meet as a group to engage in more in-depth therapeutic work.

Because the OM continued the partnership with MFS it was possible to informally keep in touch with the women. The reality of their lives was brought starkly home when one woman was deported soon after the project finished and was not able to join the group for International Women's Day. We hope she is safe.

A good partnership is like a good recipe, it is more than the individual ingredients – that extra spice of life produced by the vision, chemistry, energy, enthusiasm, creativity and hard work of all the people involved. However for it to work on the ground there has got to be an agreement of exactly who is responsible for each part of the project, good communication and an understanding of the impact on the people and project of not fulfilling each part of this agreement.

MF, based in London, is a specialized support service for survivors of torture and organized violence. The MFS centre opened in response to Glasgow becoming a dispersal city for refugees and asylum seekers in 2001. Their service includes individual, group and family therapeutic programmes. MFS brought the group together – having carefully considered the participants – ensuring that they

'This makes us realize that we are not who we think we are. We have all those colours inside and when we look at these we can notice and realize that. How could we make such beauty? Because we have it inside of us. We need to do more of this as it is so powerful for us.' Participant

were ready to contribute to a group, were able to listen to the experience of others, and to commit to the timescale of the project. MFS also considered the working languages of the group and selected and paid an interpreter who would be empathetic to the project. The group were from the Democratic Republic of Congo, Uganda and Sierra Leone. The project took place in a safe, relaxing space in MFS and the women involved agreed ground rules for the duration of the project. MFS provided childcare when possible, essential for the full participation of the women.

The OM was responsible for developing and facilitating the project in discussion with MFS in accordance with the needs of the group and philosophy of MFS. We organized a visit to the Burrell Collection and facilitated object-based sessions at MFS as inspiration for the project.

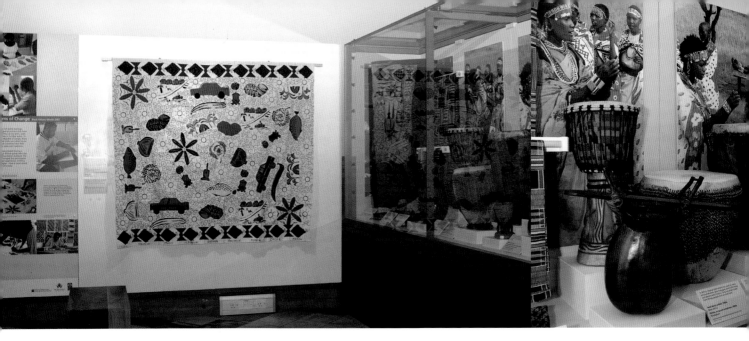

We also sourced funding for and selected an empathetic artist, who facilitated the clay based workshops, sourced clay, glazes and tools and arranged for the firing of the pieces at ProjectAbility, a well-respected inclusive community arts project based at the Trongate 103 arts facility in Glasgow's city centre. We were also responsible for the design, build and installation of the exhibition in the MFS space.

The positive impact of this project led to the OM and MFS working together on two further projects. In *Patterns of Change*, a mixed gender group worked with the artist Londi Beketch on a textile project which was displayed with objects from Glasgow Museums' World Cultures collection for an exhibition at Kelvingrove's community exhibition space during Black History month in 2007. This became a case study in *Museums Journal*. Subsequently *Together We Can* was a textile project created by a multi-lingual group of women in response to the *Colours of the Silk Road: Susani embroideries from Uzbekhistan* exhibition at the Burrell Collection with support from the artist Jan Nimmo.

'Having worked with clay and seen the final display means whereas previously we thought that people who made those things were special, magic, artists, we now know that this isn't the case.'

Participant

As museum professionals we should be looking at what our colonial museums mean to the colonized and how we can change enough for new audiences to cross our thresholds and engage happily with museums themselves.

Pat Allan, Curator of World Cultures

COMMENTS

Above: the *Patterns of Change* exhibition at Kelvingrove's community exhibition space.

'It's pure brilliant man!
Much better than playing
out in the street.' Participant

Originally from Australia,
this platypus is now part of
Glasgow Museums' collections.
Duck-billed platypus.
DB.10368

THEY COME FROM A LAND DOWN UNDER

Sarah Cartwright

Participants:
Calvay Centre, Jeely Piece Club, Molendinar Community Centre
Number of participants:
8–10
Location:
Calvay Centre, Easterhouse, east Glasgow; Jeely Piece Club, Castlemilk, south Glasgow; Molendinar Community Centre, Provanhill / Blackhill, north-east Glasgow
Duration:
April 2008–ongoing

A good community centre should be the heart of the community and be an integral part of a community's well-being. It should involve the community and its opening hours and activities should respond to users' needs. It should be a place to meet, learn and play.

Community displays are one of the OM's main strands, created for and housed in a variety of venues across Glasgow. Designed to increase the level of access to objects from a wide selection of our collections they allow objects to be viewed within community settings, increasing our audience development and reducing access barriers for museums. Castlemilk is a district of Glasgow to the south which has suffered social problems associated with poverty and unemployment in its recent past. The Jeely Piece, established in 1975 by local parents, linked into the 1980s regeneration strategy for the area which was focused on improving housing and amenities for local people. A swimming pool, sports centre, shopping arcade and community centres have since been developed.

The Jeely Piece consists of an indoor and outdoor play centre which caters for children aged pre-5 to 16, but also provides adult leisure and training classes. It is community-run by a registered Scottish charity and a company limited by guarantee.

Left: two young people from the Jeely Piece Club enjoying designing and painting the core for the Australian mini-exhibition.
© The Jeely Piece Club

Located within a housing estate, there are very few other amenities in close proximity. This has a tremendous effect on the validity of the small museum displays which are biannually re-displayed at this venue. Customers are always particularly interested when we are changing the mini exhibitions. Their interest and enthusiasm is evident through the integral role that the young people of the Jeely Piece play in designing the back drop of each exhibition.

The display case at the Jeely Piece is one of two such mini-exhibition cases, the other of which is located in the Molendinar Community Centre (MCC) in the north-east of the city, but was previously housed for around 18 months in the Calvay Centre in Easterhouse.

The co-operation of the play workers is always forthcoming and the time and energy spent by the young people to create the ideal setting for the museum objects is unmistakable. This also develops a sense of ownership and pride about the museum display, particularly as it moves from the Jeely Piece to MCC where it will be viewed by others.

A recent exhibition was created on the theme of Australia and the unique variety of Australian wildlife. Three natural history specimens were chosen, a platypus, a kookaburra and a stump-tailed skink. The job of creating the backdrop was passed to the play workers at the Jeely Piece who helped the young people design and paint the core based on the Australian theme. The only drawback encountered was their representation of the Australian Outback, which involved gluing sand to the bottom of the display, which created some logistical problems for the OM's technician, due to this additional material on the base of the core.

These two display cases were originally developed and created for a previous OM project and tend to attract people due to their size and distinctive mobile phone shape. The small displays are able to be moved from one exhibition case to the other, allowing a continual exhibition cycle and also giving different areas of the city the opportunity to view the museum objects.

MCC is sited in the Provanhill/Blackhill area of Glasgow, which is located to the north east of the city centre and neighbours the peripheral districts of Springburn and Carntyne. Over the past 60 years this area has suffered major deprivation associated with acute housing and drug-related crime problems. This area has limited amenities for local residents, with the MCC the only local resource. The nearest library is across the M8 motorway in Riddrie while the closest leisure facility is located in Springburn, just over two miles away, geographically separated by the M80 motorway.

MCC follows a similar approach to the Jeely Piece. It currently houses not only the mini-display but also one of the OM's twenty travelling displays. Managed by Glasgow Life, it adheres to the idea of creating a community facility to meet the needs of the surrounding community. Users are from the locality and appear to respond positively to our displays. So far the young people have not been involved in designing the backdrop for the mini-exhibitions, however there is definite interest in the possibility of being engaged in the creation of future re-displays.

Above: the Molendinar Community Centre.

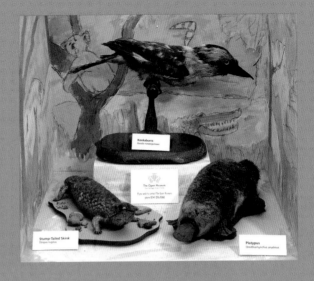

The Calvay Centre is located in Easterhouse, to the east of Glasgow city centre, one of several large housing projects built in the post-war years. It came to prominence in the wider world through its social problems, linked to its lack of basic amenities. The 1980s regeneration strategy by Glasgow City Council and Glasgow Housing Association focused on improving housing quality and local services. Leisure facilities now present in Easterhouse include a swimming pool, sports centre, library, an arts centre and a resident artist. However the area is geographically divided by the M8 motorway and A8 Edinburgh Road, restricting access for some residents to these amenities which are all located in close proximity to one another.

Unlike the Jeely Piece, the Calvay Centre was not a successful location for the museum display case and although it provides similar activities for the surrounding community and is also run as a charity it does not appear to thrive.

It is important that our relationships with community centres such as the Jeely Piece Playzone and MCC continue to develop and grow, to create future opportunities for the people of Castlemilk and Provanhill by enabling them to access and experience museum objects first hand, but also to provide a successful template to forge links with other community centres across the City of Glasgow.

Even small displays make a big difference to empowering the development of local communities but this does not relate in turn to the amount of work required to put these displays in place. Relationships must be built, developed and maintained, resulting in a working model. The question remains as to what ingredients are missing when the same plan is followed – as was the case with the Calvay Centre – yet is ineffective?

Above: the Australian natural history specimens installed in the core designed by the young people at the Jeely Piece.

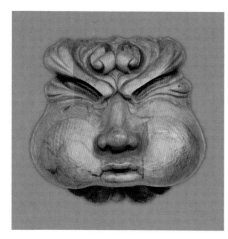

Above: Winds of Change
Wood. Temp.20404
This work of art inspired the figurehead for the Ark,
carved by the community based GalGael Trust.

Right: ship model 'Helping Hand', wood and fabric,
made at Rock Channel shipyard, Rye, 1921.
LT.1973.12.AD

THE GARDENERS' ARK

Claire
Coia

FACTS

Participants:
**Adult Learning Group,
Leverndale Hospital and
Dykebar Hospital**
Number of participants:
9
Location:
Leverndale Hospital
Duration:
April 2009–October 2010

The Gardeners' Ark project is a mass of tangled roots and shoots. Glasgow Life's Community Learning Team had approached the OM to help develop new ways of working with an adult learning group from Leverndale Hospital. After a considerable amount of groundwork, the initial seeds were sown in mid-2007. The first partnership was set up and an initial short-term project realized, resulting in a display in the Mitchell Library as part of the Aye Write! Festival. From there the OM saw the potential in developing a deeper involvement with this group. New seeds were planted and allowed to develop organically – more partners and group members came onboard, the project grew, and the result is an abundance and variety of fruit that is 'The Gardeners' Ark'.

Left: the Ark at the Winter Gardens of the People's Palace, August 2010.

The many strands of this project mean that there are lots of inspirational objects that were selected – from ship models and seascapes, to cyanotypes, to sculpture. The most obvious choice might be our star boat model or the Scottish painting *Home from the Herring Fishing* by Robert Weir Allan (1852–1942), which heavily inspired the form the travelling display took – essentially a 10ft boat built by the group, that has come to be known as the 'the Gardeners' Ark'. Filled with plants grown onsite at Leverndale Hospital, the Ark is the most visible outcome of the project which tours Glasgow throughout 2010.

The participants are long term residents at Leverndale Hospital. All have mental health issues, some with physical or motor impairments, and a wide range of learning difficulties. Most have spent their lives in care from an early age, and have somewhat limited life experience outwith the familiarity of the hospital. Some can be deemed difficult to engage with due to the nature of their illness or because of the challenging behaviours they present but the overall aim for this group is rehabilitation into their community. Some may move on, while others spend the rest of their lives in care. We had to take all these factors – and more besides – into consideration whilst trying to ensure that the project was of value for the range of residents involved.

Part of the project included an art-based assignment conceived by one of our Outreach Assistants, Catherine Laing. This involved bringing rare and fragile cyanotype prints by celebrated botanist and photographer Anna Atkins (1799–1871) out of the museum environment and into Leverndale Hospital. The group learned photography techniques and created cyanotypes and artworks using organic materials from their own gardens. Armed with these new skills, the group came to visit the stores at GMRC. They brought prize winning fruit and vegetables that they had grown onsite, selected ceramics from the collection, and studied still-lifes in the Fine Art store. The photography studio was set up and the group arranged their individual still-lifes. Under the guidance of our professional photographer, they were encouraged to play with lighting techniques as their compositions were photographed.

Above: Alana Esculenta, collected at Cumbrae, December 1892. 14.52

Above, left: Anna Atkins cyanotype, *Alana Esculenta.*
B1980-16-146

Below, left: inspired by the cyanotypes of Anna Atkins, the participants also captured images of plant life in this medium — the only difference is that the group grew the plants themselves!

The object that really brought this project to life for me, however, is a jewel-like painting – *Still-life with Fruit* (*c.*1853–1900) by Antoine Vollon (1833–1900). The last participant to compose their still life requested a knife to 'cut a triangle' out of the huge marrow that they'd brought for the session. We were confused by this, but it then dawned on us that he wanted to cut a slice from the marrow so that it would look like the melon in the Vollon painting. This was a breakthrough. The participant had been directly inspired by the painting and had taken composition techniques fully on board with his own creative flair.

The Gardeners' Ark's success is also dependant on the expertise of partner organizations. It draws on the experience of Leverndale Hospital's Occupational Therapy team and their rehabilitation programme, as well as their long-term relationship with Glasgow Life's Community Learning Team and Acorn Gardening. It is essentially a three-fold operation encompassing art therapy, literacy and horticulture.

The majority of the group are involved in the Acorn Project – a long-standing initiative that aims to support rehabilitation through gardening. It provided the core rationale behind the project, integrating the key strands of rehabilitation, literacy work and art therapy into the residents' daily life.

Had the OM stepped in to do a one-off project without a wide network of partners and support we would have failed on any meaningful level. The group find it hard to build up trust – progress is slow and often frustrating. To have forged those bonds on a short-term basis with no lasting legacy would have done more harm than good. This project is therefore based on a holistic approach, bringing together the different strands of daily life at Leverndale, focusing on long-term rehabilitation and creating pathways of opportunity.

A publication is currently underway, featuring the results of two years of work and will be part of the lasting legacy for this project. Glasgow Life's Community Learning Team works with the group on a weekly basis to develop literacy and numeracy skills, tailored to suit the diverse priorities and motivations of each individual.

Above left: Still-Life with Fruit,
Antoine Vollon (1833–1900),
French.
Oil on panel, 425mm x 721mm.
Bequeathed by James Donald,
1905. 1109

*Above right: Still-Life with
Marrow, participant.*

This is an essential step towards rehabilitation for the participants – being able to connect with the outside world, including communicating with their families while based within the hospital – in addition to the basic skills required of independent living.

The outcomes of this project include a 'living' travelling display, an on-site exhibition, and online content, in addition to the publication. The visible outcomes are like the contents of a fruit bowl, with no indication of the tree from which they grew, the gardeners, or the produce still to yield.

Much of the work done by the OM is like this, particularly with sensitive, demanding and complex projects. On the surface of it, we are seen to glide, but our feet are paddling furiously underneath. And we often find ourselves in unknown waters.

'I am outside in the fresh air and it keeps my mind busy.' Participant

COMMENTS

...the project has supported developments in the group members self esteem, confidence, socialization and importantly their sense of fun and enjoyment.
Louse McGinley, Senior Occupational Therapist, Leverndale Hospital

My tutor's helping me to write better and spell better. My spelling and writing and work has improved.
Participant

You can feel better by doing a little every day and working at it.
Participant

The participants created a step-by-step planting guide for the less green fingered among us. This is the first step – the planting of the seeds.

Ceramic cup,
from Coia's Café,
Duke Street,
Glasgow.
Temp.2303.1

Mary Johnson

FACTS

Participants:
The Achievers Women's Group
Number of participants:
15
Location:
Disability Community Centre, Possilpark, north Glasgow
Duration:
28 May 2009

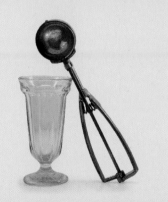

Above: glass sundae dish, from Crolla's Café, Main Street, Bridgeton. PP.1986.25(i) and ice cream scoop, metal, from Coia's Café, Duke Street, Glasgow. Temp.2303.7–57

Reminiscence sessions are important not only for individuals and groups but for those delivering the sessions, providing us with rich information on objects and ever enhancing Glasgow Museums' collection. They are a key service of the OM. They can be one-off sessions or part of a larger project, allowing participants to touch and hold a museum object, giving them time to tell their story. The following story shares with you a reminiscence session where we used one of our most popular kits – the Cafés reminiscence kit.

Just one object has the power to draw us back in time to a place of importance, allowing us to share these memories and emotions with others. The Bovril cup is a great object to use in a reminiscence session because Bovril is still used today, which provides us with the ever-important contemporary connection, yet it has the ability to draw us back in time where fond experience can be shared.

'I asked owners from original Italian cafés in Glasgow what objects they'd include to tell the story of Glasgow Cafés and a coffee or Bovril cup was top of the list!'

Frances McCourt, OM Outreach Assistant, 2005–08

Once upon a time there was a cup, a fairly insignificant, plain and ordinary cup. Small, white, with a little handle, and the word 'Bovril' scratched into its side. It was a cup used every day in cafés around Scotland, providing customers with its wholesomely flavoured drink. However time came to pass and people were happy to use any cup to sup the brown-coloured drink from and eventually the plain, ordinary cup with 'Bovril' on its side was left in a dark cupboard. Then one day it was taken to a museum. The little white Bovril cup was cleaned, given a number and placed on a shelf with its whereabouts recorded. Only this time it was not next to the plates and the ice cream dishes. This time it was next to ornate vases and silver spoons, which came and went as curators lavished their affections on these artefacts. Eventually it was decided this 'artefact' had a great story to tell.

Our 'Cafés' kit was developed in 2007 by Outreach Assistant Frances McCourt, and was designed to take you on a journey round Glasgow's cafés past and present. Inside the kit there are photographs and museum objects such as menus, chocolate boxes, an ice-cream scoop and a jelly mould. Quite surprisingly one of the star objects in this kit happens to be a seemingly ordinary, little white cup with a little handle and the word 'Bovril' etched into its side.

Leading reminiscence sessions can be quite nerve-racking. One way to ease that feeling is to go out and meet the group beforehand. Catching up with the group in their space and chatting with them really helps focus a reminiscence session around their interests. You also have the added benefit of seeing the space and recommending small changes that will help create a more intimate setting. These preparations benefit any session, ultimately helping deliver a better, more relaxed gathering.

Feeling confident in the kit chosen for the group and the space for delivering the session we set out to the centre. When we got there the group had organized the area and were eagerly awaiting our arrival. We began by bringing out the paper objects – the Dairy Milk Display Bar started a debate about the price of chocolate in the 1950s which then moved onto stories about decimalization and the changing size of chocolate bars. The participants were interested to learn that modern metal ice cream scoops have anti-freeze inside the handle to make dishing out different flavours of ice cream that little bit easier.

But it was when we took out the Bovril cup that participants really came to life and their stories became more personal. Stories of going to cafés and drinking Bovril on their first date, of how they would save money all week to go out at the weekend, see a couple of movies, go to the café and end the night with a cup of hot Bovril. Sadie O'Hear said 'After the pictures we thoroughly enjoyed getting a cup of Bovril and cream crackers…. that was 50-odd years ago'. Another participant claimed Bovril was only to be drunk at football matches! If money was tight an Oxo cube was used instead. Inevitably, the cup of Bovril was followed by a puff on a cinnamon stick! A woman revealed how she still sucks on half an Oxo cube. We were told how Jock's café in Bathgate gave you any drink in the Bovril cup. Imagine drinking anything other than Bovril from that cup! Love or hate it, Bovril is recognized as one of Britain's favourite drinks. Originally invented by a Scottish man in 1871 to nourish Napoleon III's army, 'Johnston's Fluid Beef' became known as Bovril in 1886, and by 1909 it had become the staple drink at football matches – so maybe the group have a valid point.

The Achievers Group started in 1994. They were a group of women who were overcoming a serious illness. The aim of the group was to bring laughter into their lives – which they are still achieving today! The group meet once a week at the Disability Community Centre, sharing their skills with each other, listening to guest speakers and having pamper days. Every fourth week they try to get out to visit a museum, go to a garden centre or have an ice cream by the sea. They had heard about the OM's lending service and while it became clear during their induction they did not have the means to borrow kits we were able to offer them an alternative and hold a reminiscence session in their centre. The Achievers think our reminiscence sessions are excellent and love being surprised by what's inside the boxes!

There were no issues with this reminiscence session mainly due to the good working relationship with the group and the preparations done beforehand. Quality of service should be at the forefront of people's minds when preparing, delivering and evaluating reminiscence sessions. The OM always recommend that time is taken with a group and a visit is made to an intended venue. Reminiscence sessions provide audiences with a unique way to view an object, one which is not experienced by the museum-goer. In delivering a reminiscence session all of us experience the power that the strength of touch holds. Such sessions are important for the individuals and the groups taking part and for those delivering the sessions. Their very nature allows individuals to personalize each object in ways which always enhance any collection. For the person delivering the session, the reminiscences can inspire other activities involving other user groups, therefore taking the collection much, much further afield. This is why reminiscence sessions should be an integral part of the upkeep and development of any collection – they help build the heritage of the past and the future.

Above right: a participant holds the Bovril cup during the session.
Below left: the Italian café represented a real focal point for many Glaswegians in their communities and lives.

'The café culture was of real value in people's lives, providing a place to go before or after "the dancing" or "the pictures" or just somewhere to meet up for a chat or to listen to the latest music.'

Frances McCourt, OM Outreach Assistant, 2005–08

RECOLLECTIONS

Jaime Valentine

Museums have traditionally been seen as guardians of the past, storing treasures collected by the few for the enlightenment of the many. In this sense, for a museum to be open is either true by definition (public museums as open to all) or a contradiction in terms (the custodians of culture as an inherently closed circle of collectors). This is reflected in the notion of the 'permanent collection' that conjures up universal and unchanging credentials for inclusion. The problem with these assumptions is that cultural consumption is socially limited, and what is included can be characterized as exclusive. Museums are open only to those with the requisite cultural capital, familiarity with the codes to interpret 'our' heritage. A museum that is open in a more radical sense places outreach at the centre of its vision, not only in going out to educate and familiarize with existing collections, but in ensuring that the collections reflect a shifting diversity – reaching out to the un-represented to empower them to reach in, re-collect and reconstruct heritage.

Heritage is central to identification – we incorporate a version of our past into the account of who we are as individuals and communities. Personal identity and wider culture can be seen as works of 'bricolage', whereby we assemble and recollect ourselves, drawing on a range of what is available, the 'stuff' that surrounds us. The process is characterized by inclusion of what is self-consciously ours, neglect of what is beneath our recognition, and exclusion of what is considered 'other'. This remains true at the level of individual identity, put together as a provisional and transitory collection, constructed with and against others. The boundaries of who we are, the outlines of our portrait, are defined by visions of what we are not. Far from being static, identification is constantly re-grouped, incorporating personal memory and collective heritage as shifting compositions, recollected according to the concerns of the present.

The challenge for an open museum is to reflect this variation and diversity without reifying difference. The twin danger is neglecting people or stereotyping them.

A museum collection in which you can find no reflection of yourself is hardly improved by a representation of you and yours that sums you up in one-dimensional terms. Behind a standard or official version of a culture there are hidden histories, as witnessed in the contribution of Glasgow's Asian community to the city's transport system, or the spaces in the city where lesbian, gay, bisexual and transgender people could meet each other. These neglected narratives tell a different history that has been ignored or suppressed, mapping the city in unacknowledged ways.

Museum collections tell stories, providing implicit or explicit accounts of our heritage. Recognizing this, and using it to examine what objects mean for people, can be an impetus for re-collection. Matching personal stories with museum objects is a two-way process, and collecting stories can expose gaps in the collection of objects, encouraging the incorporation of material that reflects people's experience. An example is the gap in contemporary music and media revealed through stories heard at Yorkhill.

The interplay of objects and stories is at the heart of the OM's object handling kits, whose contents both embody and generate recollection. In collecting the kit together, a community comes to recognize similarities and differences of remembered experience – sharing memories can spark further reminiscence. Outreach that takes a reminiscence box beyond its community of origin can do more than merely educate and inform. It may stimulate other groups and encourage identification across boundaries. Inspired by their experience with the

OM, OurStory Scotland and One Place Storytelling Workshop developed the *Love Out of Bounds* project in Govanhill. People from majority and minority ethnic communities, irrespective of gender and sexuality, find commonalities in stories of love unaccepted by family, community, faith or culture. The *Wall of Mystery* project at Yorkhill illustrates unpredictable and creative ways that objects can be put together from across cultural boundaries, creating a display that explores an understanding of history in relation to the young people's own lives.

Reminiscence has often been thought to be the prerogative of older people, but this is belied by the OM's innovative work with young people. Recollections shift and need recording at the time, not only for the current involvement of the young, but as enduring documents of change. This provides a motive for participation in OM work with organizations such as Yorkhill Hospital and OurStory Scotland – we collect and recollect so that future generations will know what our lives were like. Some lives are notable by their absence, as in the lack of objects that reflect residence in a Glasgow high-rise. There is a time-limited opportunity to recollect a distinct way of life at a particular time, drawing on living memory to feed into museum collections and community engagement. The role of the OM in reflecting diversity and change shifts the emphasis from museums as custodians of pre-ordained culture to museums as arenas for re-collection, contesting assumptions of who and what is represented.

If we feel we are represented in a museum, we see it as ours. If not, it is not our heritage and we may feel that little value is placed on our stories, our culture, ourselves. One of the most common responses encountered by oral historians is 'my story is nothing special'. Collecting narratives and artefacts can be validating for the individual and community, and their participation as collectors is a source not only of material for the museum but also of empowerment.

Everyone collects. A museum can turn the sometimes embarrassing admission of hoarding, or a more particularly focused obsession, into the valued role of contributor to heritage. The OM has been pioneering in developing recollections from diverse communities, giving them a voice in the collecting process. The collection comes alive through the contribution not just of artefacts but of narratives that lend them significance, stories that illuminate the meaning of objects, recollections that are profoundly moving, beyond the boundaries of any one definition of who we are.

Jaime Valentine
Chair of OurStory Scotland, Honorary Senior Research Fellow, University of Stirling

Muffin the Mule, *c.* 1950s
Metal, Manufacturer
unknown

'I didn't play at collecting. No cigar anywhere was safe from me.' Edward G Robinson

Hello. My name is Kevin and I am a collector. Now that I have got that off my chest I feel we can all move on and enjoy the rest of this chapter. I'm being silly, obviously, but people who collect things (let's stick our necks out and call them 'collectors' shall we?) will remember at least one occasion where they were asked publicly about their hobbies and found themselves shifting uneasily while stammering apologetically around the subject. This seems odd really.

After all, our ancestors were hunter-gatherers and 'collected' in order to survive, so you could argue that as a species we are very much hard-wired to instinctively seek out and collect things. What I am saying is that the things we collect tell us much about both ourselves and the society we live in. They also tell us about our relationship with the material world and, importantly, the value we bestow on objects of desire.

So why collect anything at all?

Rubik's Cube,
1980, Plastic, Ideal

Thunderbirds, 1992
Plastic
Matchbox

Every collector will give you their own individual reasons for surrounding themselves with specific groups of objects. For some it invokes childhood memories, for others it is straightforward 'fanboy' obsession, where someone focuses on a particular celebrity or film. Star Trek fans, or 'Trekkies', are a perfect example of the tenacity and obsession of fans who love their subject matter and lust after anything that is remotely connected with it.

If contemporary museum commentators are to be believed, it is a deep-rooted psychological trait that drives us to collect and the reason we do it so obsessively is to create individual identities for ourselves. Whatever the reasons it is clear that a great number of people collect something – whether it be family photographs, souvenirs from holidays or even online friends on a social networking site.

Take one of the most famous collectors in the world, Sir Henry Wellcome, the well-known businessman and philanthropist who amassed a collection of over one million objects in his lifetime.

Wellcome wanted to create a Museum of Man and believed if he collected enough objects they would somehow unlock the secret of mankind. As strange as that sounds, it became his motivation to zealously collect millions of seemingly random objects – everything from Napoleon's toothbrush to over 100 safe doors made it into his collection.

Sir Henry Wellcome died while still collecting and unfortunately his museum was never established, in fact his collection was broken up and sold off, but his legacy was to be of the greatest private collections ever made and incredibly, his trust still funds projects today. Glasgow had its own high-profile collector in Sir William Burrell, whose extraordinary private collection was bequeathed to the people of Glasgow and is now housed at the Burrell Collection in Pollok Park. Now, you may say both Wellcome and Burrell are extreme examples of collectors, but it occurred to me that the common factor in their story, other than their limitless funds to buy objects of course, was the personality and motivation of the individuals.

I collect old toys and games and have done so most of my adult life. But I have often reflected on how and why it all started. It is true to say that when we grow up most of us put away our childhood belongings, things that were so precious to us when were children. From our early teens we are encouraged to 'grow up' or 'act your age'. Perhaps we can even interpret passages from the Bible as meaning God wanted us to stick our metaphorical toys in the attic!

When I was a child, I spake as a child, I understood as a child, I thought as a child: but when I became a man, I put away childish things. 1 Corinthians 13:11

Sensible advice I suppose, but how do you put away something as brilliant as Knight Rider Scalextric or an Action Man complete with helicopter backpack? For me, collecting toys began as a way to evoke those warm and fuzzy childhood memories (rose-tinted or not) and of course to own the toys that rocked my childhood world all those eons ago.

Don't get me wrong, I'm not trying to plug gaps in a toy-deprived childhood. I had the best upbringing anyone could ask for. I had as many toy-crammed Christmas mornings and birthday surprises as any other boy, my age, in my street. I wanted for very little (even though my parents were by no means well-off). But you couldn't have everything unless you were spoilt rotten or perhaps lucky enough to get onto programmes like *Crackerjack* or Noel Edmond's *Multi-Coloured Swap Shop* and be simply handed armful of tantalising 'must-have' toys. But that was never going to happen and I knew it even as an optimistic nine-year old.

The point here is that collecting is both fun and relevant. Those who dismiss the notion of collecting

as trivial or a waste of time, miss the connections it has to life and indeed how it fulfils a very important need to surround ourselves with the things we love, just as we do with friends and family or pets or anything else.

So what do we collect?

Well, it seems everything! For some, like me, it began in childhood with football stickers, marbles and souvenirs from days out and holidays. I always seemed to be collecting something. Sometimes it was comics, then dinosaur figures and eventually (like many young lads before and since) I became a devotee of the *Star Wars™* universe.

I was always a bit of a collector. I could often be seen sticking postcards in diaries or constantly sketching, scribbling and drawing and 'storing' the postcards under my bed. Often it would snowball into what I can only call a 'hobby' (the innocent child of 'collecting') and before I knew it I was fixated on completing my collection. But collecting stuff is not just limited to the usual subjects, such as stamps or train numbers – people can and do collect mouse-mats, man-hole covers, banana labels and even barbed wire!

Right: Star Wars figurine, 1977 Plastic

Left: Magic Robot, 1954
Plastic, Manufacturer unknown

Right: Power Glove, 1985
Plastic, Famicom

For some people it is collecting the really unusual items that works best for them.

And what scientific names do we give our friends the collectors? Well, a 'tegestologist' is someone who collects beer mats – while a 'conchologist' collects shells and the rather ominous sounding 'arctophile' refers to someone who actually collects teddy bears. Whatever your phylum, the chances are that your fate was sealed the day you went on holiday and slipped that nice looking hotel matchbox into your pocket or purchased a few extra postcards or even kept that rather unusual looking air sickness bag from the flight.

But collecting is not all fun and games. There is the frustration of just not being able to complete a collection of porcelain hedgehogs.

Left: Sinclair ZY81,
1981 Sinclair Research

And there is no pain that can compare to being 'sniped' on an online auction with three seconds to go for that one object that could have raised the profile of your collection into legendary status.

Disappointment can come with the territory. Recently I got excited about the prospect of displaying my toy collection in a small local museum. There were neat little cards with polished words saying what my toys were and proper display cases that people could peer into. For the first time I would have my entire collection on display, with the added bonus of achieving the 'Holy Grail' of collecting – to have people come and appreciate my stuff.

After two days of meticulously arranging my fine collection of toys in classic poses, I stepped back to take in the display and was full of pride and excitement. People came and went and everyone appeared to enjoy the toys and indeed the stories behind them. I soon realized however that despite genuine public interest in the subject and visitors really engaging with what was on display, they did not share the same level of passion that I had in the subject. But in the end, does that matter? Not a bit.

Any initial disappointment that I ever felt about people's levels of enthusiasm not matching my own soon diminished and was replaced by a quiet satisfaction and suppressed joy at seeing my collection, unboxed, all together and on display! But the best experience in all this was to mingle in the gallery with visitors, listening to their conversations and reminiscences, inspired by the displays. That, for me, is the essence of collecting – it is a constant reminder of who you are.

So whether you collect actual physical objects or even experiences (I have a friend who 'collects' football grounds by visiting them and ticking them off in a little book) it is clear that it can be both a hobby and an obsession, but more importantly collecting stuff brings passion, fun and interest into our lives.

Below: Queen's cast iron stove, 1920s
Iron

Above: Operation, 1965, MB Games

'I pick things up. I am a collector. And things, well things they tend to accumulate. I have this net and it drags behind me…'

'The Collector', Nine Inch Nails

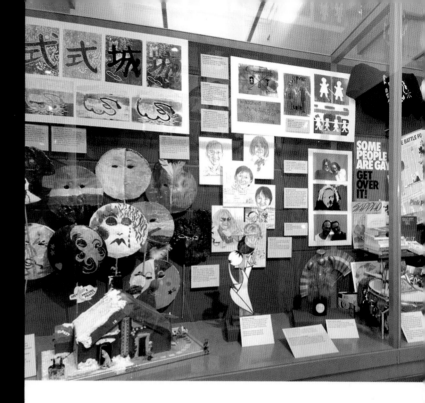

Above: the *OurStory Scotland* exhibition at Kelvingrove's community exhibition space.

Below: Learning assistant John Irwin and former outreach assistant Ewan McPherson engage people in discussion about the objects from the LGBT kit, February 2008.

Objects are integral to our personal histories but can also be an important documentation of a collective shared history. Glasgow Museums' permanent collections have become more representative of people's lives across the communities of Glasgow through objects accessioned into the collections as the result of Open Museum partnership projects.

The LGBT history kit was developed in partnership with OurStory Scotland, a registered charity, who collect, present and archive the stories of the LGBT (lesbian, gay, bisexual and transgender) community in Scotland. The OurStory box is full of objects, donated by members of the group, each of which was significant to the identity and life story of its owner. Many also mark significant events in LGBT history in Scotland – a history being told from within the community and inclusive of its diversity.

It is hoped these objects will inspire people to add their stories to the visual, verbal and dramatic storytelling process, facilitated by OurStory Scotland, which is contributing to a national archive of LGBT lives held at the National Museums of Scotland.

The kit launch coincided with the launch of the *OurSpace* exhibition in the Kelvingrove community exhibition space for LGBT history month in 2008. It is a great inspiration for intergenerational work, to document changes in LGBT experiences in Scotland, to educate on diversity, explore civil liberties and inspire other communities moving from the margins to become part of a diverse Scotland that is proud of its many communities and cultures. Its music, books, T-shirts and badges can enable a wider exploration of personal histories and social change. It is an example of a proactive partnership which has fed into a wider social justice agenda.

Above: a miniature replica of an original T-shirt from the LGBT kit.

Opposite, above: a bottle of 'Quorum' aftershave, one of the handling objects from the LGBT kit.

Opposite, below: a collection of original badges from the LGBT kit.

'When I worked on the LGBT history kit, so many people I debated and told stories of the objects that were selected – it was wonderful listening to the stories provoked by the passing round of a mere badge or old lesbian and gay rights newsletters, worn and passed around in the days before gay rights became law. it made me thankful to live in the time I do now, and it felt a privilege to work in the OM to hear this.'

Ewan McPherson, Outreach Assistant

COMMENTS

COLLECTING OBJECTS AND EXPERIENCE

71

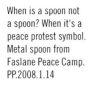

When is a spoon not
a spoon? When it's a
peace protest symbol.
Metal spoon from
Faslane Peace Camp.
PP.2008.1.14

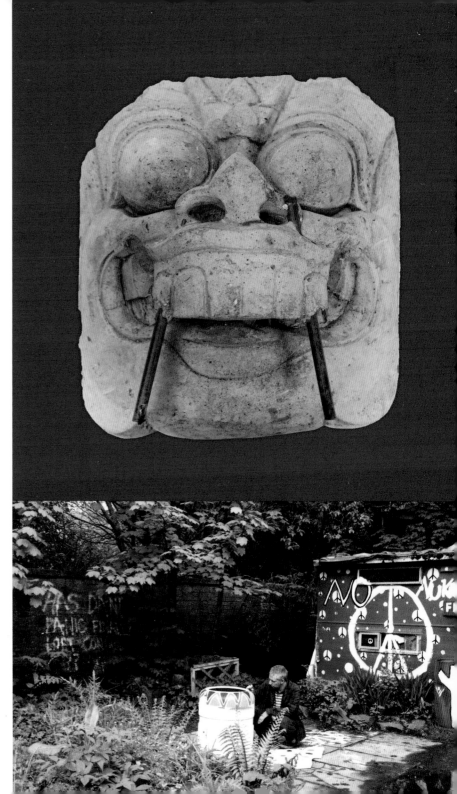

Right, above: head
cast, concrete. Made by
peace camper Steve Cox.
PP.2008.1.22

Right, below: working on
the touring exhibition at
Faslane Peace Camp.

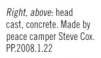

Above: caravan from Faslane Peace Camp, collected in 1998 and displayed at the Museum of Transport. T.1998.4a.1

Right: Gonk doll, from Faslane Peace Camp, collected in 1998. PP.2008.1.12

Participants:
Faslane Protestors
Number of participants:
c. 20–30
Location:
Faslane Peace Camp
Duration:
1998

FACTS

Collecting the Faslane Experience

Fiona Hayes & Laura Murphy

How do we ensure community engagement informs the development of museum collections, the acquisition of material culture? In human history terms the museum collection becomes representative of collective human experience. It validates that experience through what is and what is not acquired for the museum collection.

When the OM exhibition the *Faslane Peace Caravan* was dismantled after almost ten years of touring there was a question about what should happen to the objects in the display. We were keen that the items in the display should become part of Glasgow Museums' collection, as they represented daily life at Faslane Peace Camp for the people living there at the end of the 1990s.

Faslane Peace Camp, established in 1982 and occupied continuously since, is sited alongside Her Majesty's Naval Base on the Gare Loch on Scotland's west coast, about 40km from Glasgow. The base is famously home to the UK's strategic nuclear deterrent – nuclear submarines armed with Trident missiles. While many Scottish politicians have joined the protests at Faslane over the years, decisions about the deployment of nuclear weapons and the renewal of Trident missiles are currently a reserved matter dealt with at Westminster rather than by the devolved Scottish parliament. Although the city of Glasgow has long since supported the anti-nuclear movement this has not always been evident in our institutions.

From the start, we faced a challenge. We went regularly to work with the peace activists at the camp. But the community at Faslane is a very transitory one. Protestors were not wealthy so didn't have many belongings. We were asking them to give us items which were really important to their daily lives. The resulting exhibition was a testament to their generosity, and their acknowledgement that theirs is a story that needs to be told to a wide audience.

The peace campers chose and spoke about items they felt represented and reflected their life in the camp and why the issue of nuclear disarmament was so important to them. Their personal testimony and reflection gave the objects a context and meaning that would otherwise be missing or diminished. For some aspects there was no material evidence, only the spoken word. Many people interviewed mentioned the campfire as a significant factor in creating a sense of community and solidarity in the camp at the time.

Some objects, like the *Faslania* magazine and the Happy New Year poster, show a sense of community and continuity in the camp. Other items underlie the peace campers' commitment to the anti-nuclear message.

'What sums up Faslane Peace Camp for me? A lock-on clip. It's a piece of chain in a loop with a climbing hook attached to it, and the lock-ons that we use are a tube set in concrete. It's an eviction defence.' Simon

Above, right: Jimmy's head torch which he used while making tree top platforms and tunnels. PP.2008.1.23

Above, top: refuse collectors at the naval base found this model submarine in a bin and handed it in to the Peace Camp. PP.2008.1.20

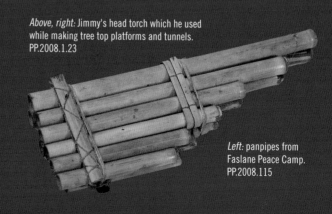

Left: panpipes from Faslane Peace Camp. PP.2008.115

We had a great exhibition launch event at the Queen Margaret Union at Glasgow University, with amazing bands and DJs, and there was a sense of pride from the peace campers, that their personal stories would be kept for future generations.

Looking at the artefacts now accessioned into our collections and reading the transcripts from the interviews we get a sense of life in the camp at the end of the twentieth century and the peace campers' motivations. From Jenny's firestick, Paddy's didgeridoo and six-year-old Jessica's drawing of the washing line to the head torch Jimmy used to construct tree-top platforms and tunnels at the camp, these objects and testimonies give a sense of the purpose and rhythm of daily life of the camp.

The significance of some items – like the spoon – might not be immediately obvious. Then we learn that three peace campers were arrested for tapping the fence around Faslane Naval Base with spoons and the spoons were confiscated. So the spoon has a new significance and meaning, as peace campers took spoons on actions and demos.

By adding these items to the collection they illustrate a radical 'other' voice already glimpsed within Glasgow Museums' collection. They bring a contemporary element to the collection of material that GM holds, related to popular protest in and around the city over the last 200 years. Early trade unions, such as the radical Glasgow Friendly Association of Cotton Spinners, demonstrations to obtain the vote, suffragettes, the peace movement and late twentieth-century anti-Poll Tax protests are all represented in the collection.

What is often absent are the artefacts that give a context to the lives of the people involved in these protests, explaining why they would make a stand that could place them in conflict with the law and showing that there is an alternative voice and viewpoint. The contextual contemporary collecting carried out by the OM at Faslane has created such a collection.

So, when is a spoon not a spoon? When it's a peace protest artefact.

Above: Simon's lock-on clip. PP.2008.1.19
Below, left: drawing of life at Faslane Peace Camp by Jessica (age 6). PP.2008.1.24
Below: the touring exhibition is ready to go.

Participants:
Muslim Elderly Day Care Centre, Bashir Maan, former President of Glasgow Central Mosque Committee
Number of participants:
18
Location:
Community Museum – Muslim Elderly Day Care Centre
Duration:
May 2009–March 2010

BOAC's Comet jetliner led the way in the jet travel revolution. This model led the way to a new perspective in representing Glasgow's Asian communities through community displays.
T.1995.46.750

The OM often finds itself instigating the relationship between Glasgow's communities and its museums. Sometimes it even initializes the connection between Glasgow Museums and the people who own the collections. It forms an accessible gateway to the museum experience, to the process of sharing stories and to acknowledging one's community within the context of a wider shared existence. Being at the forefront of this kind of new cultural exchange is a unique position – perhaps a situation that is exclusive within museums to outreach activity.

During the recent *Moving People* project I was asked by an elderly Asian man what a museum was. He asked in Urdu. Abhad Khan translated for me but before I had a chance to reply, he told the old man, '…it's a place where they keep old things…'. This was said half in jest and half in seriousness, but with complete sincerity.

My discussion with the man who was new to museums came in the context of putting together an exhibition on the theme of transport at the Muslim Elderly Day Care Centre at Glasgow's Central Mosque. The exhibition, called *Moving People*, looks at the Glasgow Asian community's contribution to the city's transport system.

The input from the members of the Muslim Elderly Day Care Centre was significant. Many immigrants in the 1950s, 1960s, and 1970s took jobs with the transport department – driving and conducting trams and buses around the city. In fact, during the opening of the exhibition Mr Nazim Dar narrated the story of what happened

when Pakistan and India went to war in 1965 which illustrated their story perfectly. From his point of view as a bus driver, and that of the Glasgow public, it meant that Glasgow's buses ground to a halt. So many of the then Corporation's transport department were immigrants from the sub-continent that the system stopped, as workers tuned in to radios and televisions to follow what was happening.

Glasgow's transport history is well represented within the museum collections but what of the experiences and contributions of the Asian community? How can the OM's work and remit address such a glaring gap in our collections and social history storyline?

The man who asked 'what is a museum?' clearly had no experience of one – but he was unburdened by perceptions and curious enough to ask about it. And what is a museum? It is a simple question with many answers. One answer might be 'representation'. A museum is about representing people, representing stories, representing communities and, well… representing you.

Museums need to correspond to the communities that surround them and use them, while addressing changing communities and seeking out and taking account of original thinking and new people. Museums also have a duty to address hidden history – histories that have been overlooked, excluded, forgotten, misinterpreted or just not represented at all.

Moving People began with a slide show featuring images of 1950s and 1960s Glasgow, in particular historic images of the area around the Mosque. With a view that the 25th anniversary of the Mosque's opening might interest the men's group, I delivered a presentation on the changing cityscape. With community groups things never go as expected and it was an image of a tramline that prompted a discussion on transport.

Below left: some members of the men's group view part of the *Moving People* display. The display was an opportunity to highlight the community's contributions to Glasgow's working and social life through transport.
Below right: ticket machine. T.1994.115.e

Left: Mr Hakeem Uddin shared dramatic stories of his transport experiences through the *Moving People* exhibition. He spent his career working for the Pakistani government within the aviation field. © Mr Uddin

My initial idea, to work with the themes of the Islamic architecture, the Mosque and changes in the built environment, was overtaken by the topic of Glasgow trams.

Not everyone wanted to take part but it proved easier speaking individually with the men because they could hear better and seemed more willing to engage. I built up a record of their experience of coming to Glasgow, then seeking work in transport and, more often than not, moving into business on their own.

Some stories related to transport in Pakistan, others as jobs as mechanics with the Pakistan army. Objects were selected in discussion with the men in response to their stories. One story, about Mr Uddin's evacuation from India to Pakistan in 1947, proved to be very inspirational.

Two display cases were installed, one featuring Glasgow transport stories and one featuring the evacuation story. The project highlighted that there needs to be greater focus on how communities' significant contributions are reflected in the museum collections and story of Glasgow.

One of the measurable outcomes from this project has been the new awareness that people in the Muslim community now have of Glasgow Museums as a whole and the future plan for members of the Muslim Elderly Day Care Centre to visit GMRC and participate in workshop activities. Being able to drive

these new relationships puts the OM and outreach activities generally in a prime position to address issues of representation in collections, displays and in the city as a whole. Museum practice in Glasgow looks on objects as being core to exhibition and interpretative development. The stories come from the objects. But how does this approach fit with an outreach department engaging with communities who are often not represented in the collections, let alone visitors to museums? If one aim of an outreach service is to encourage people to engage with museums then we need to be able to create collections that are relevant to them and to their experiences.

Above, right: Western SMT bus Inspector's cap, 1960s, fabric, plastic, metal. T.1989.42.9

Below: model buses used as part of the *Moving People* display.

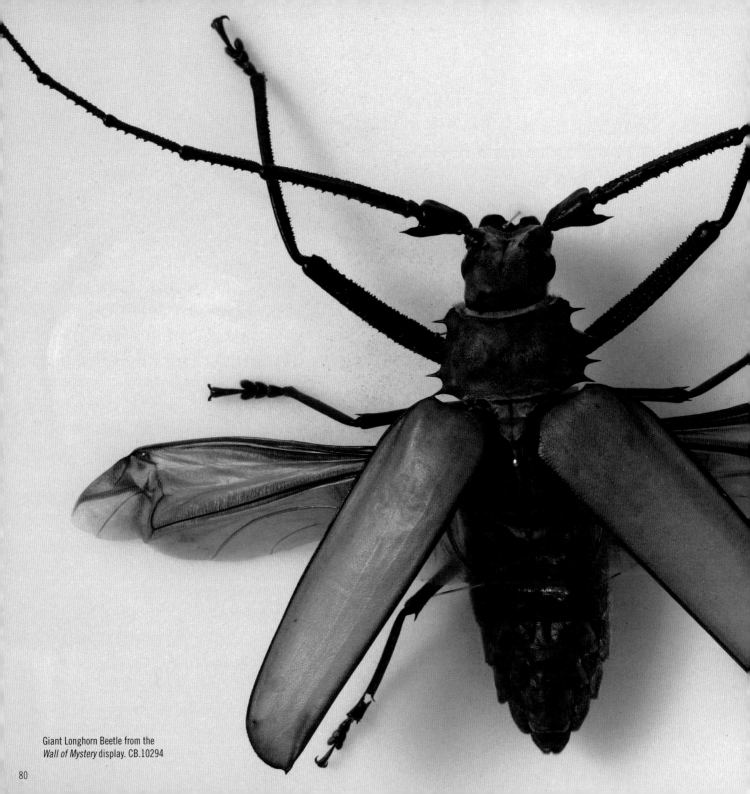

Giant Longhorn Beetle from the
Wall of Mystery display. CB.10294

FACTS

Participants:
Young people from the Royal Hospital for Sick Children Yorkhill
Number of participants:
6–8
Location:
Royal Hospital for Sick Children Yorkhill
Duration:
November 2008 –June 2009

The OM team had previously taken various object handling kits to Yorkhill Hospital. We were keen to develop a more in-depth display project, and the sense of achievement that goes with it, as an extension to the work already undertaken with the hospital. The social space used by teenagers, known as 'Zone 12+', was perfect for showing more objects from Glasgow Museums' collections – and who better to work in partnership with the OM on this than the teenagers using the space? So we approached the young people's coordinator and the project began.

The participants were recruited by going into the wards to generate interest in our plans, and we found that the teenagers were intent on doing something a bit different, especially when they realized that the display would be the legacy from the project. They were also excited at the possibility of getting out of Yorkhill Hospital for the day on a trip to GMRC.

'Love the display's beetle – it's super-scary.'

Participant

We started by looking at a selection of different objects. The young people then worked with Michael Collin, a cartoon artist, to create cartoons based on the objects. These were to be included in the final display. A visit to the OM's base at GMRC in Nitshill came next. The group were amazed at how much 'stuff' there was! During the trip they looked at objects that they thought would look good in the display – objects that other young people in Yorkhill would find interesting. They were saddened at how few contemporary objects there were that related to their own lives. No MP3 players, Wiis or PlayStations. The most contemporary computer games dates from 1982! It led to one of the young people asking 'how will people in the future know what my life was like?' If we are to fully represent the lives of our current non-users then they need to be given a voice in the collecting process. The objects they selected for the final display included Ancient Egyptian shabtis, contemporary sculpture, Bronze Age axeheads and painted glass. Their object list was then sent to the conservators who were working on the project, so that they could assess their suitability and make sure that the objects were in good enough condition to go on display. The OM's design and technical teams also got busy – they had the challenge of displaying objects in wall-mounted Perspex boxes whilst ensuring that their condition remained constant.

These were displayed in Zone 12+, interpreted by the group's thoughts and ideas. The displayed objects are currently being used as inspiration for further investigation, study and creative sessions within the space.

A project diary was created and uploaded onto the Glasgow Museums' website. This was particularly important for young people who were not local to Glasgow, providing a virtual space to show their friends at home what they had been doing.

We left it to the young people to decide whether the display should be a one-off. They decided that the project should continue and the objects on display will be used as inspiration for creative activities that will take place in the space.

The only challenge had been maintaining continuity when the nature of the group meant that members frequently changed, so this will be factored into the next phase of the project.

The young people have already started thinking about objects they'd like to include in the next display. These include shoes, make-up, costume, paintings, popular culture, animal skeletons and ancient weapons! The redisplay of the space will take place on a six-monthly basis.

Right: a participant in the project.

Above, left: 'Fantastic... it was good to see the items I had helped to choose and a variety of items.' Charlene

Below, left: objects in the *Wall of Mystery* display.

Opposite: 'jackalope' hare head with added antlers. Z.2007.30

The young people found it enjoyable and stimulating to involve themselves in a project which asked them to delve into their understanding of history, their own lives and their creativity. The nature of the sessions also meant that they were very sociable occasions which is important for isolated young people in hospital.

Sara Barr, Young People's Coordinator

While we were going round the Pods I noticed one of the girls had stickers on the arms of her wheelchair. This prompted a conversation with the group about their favourite bands and one girl revealed she'd gone to a McFly concert and managed to get back stage because McFly had come to Yorkhill hospital earlier that year and remembered her.

Mary Johnson, Outreach Assistant

Participants:
Streetlevel Photoworks,
Glasgow Housing Association,
Glasgow Life, GMAC,
Impact Arts, North Glasgow
Integration Network,
Safedem
Number of participants:
25–30
Location:
Red Road Flats, Springburn,
north Glasgow
Duration:
2009–2013/14

The Open Museum has the opportunity to engage with communities at the same time as developing museum collections, contacts and knowledge. A chance to think clearly about what to collect.

©Newsquest (Herald & Times)

FACTS

The Red Road Flats were home to 4,500 people. Built between 1962–69, the eight tower blocks are sited on the north-east side of Glasgow – their 'grandiose scale and experimental nature' has marked them out on the skyline and in the city's story ever since. After a mere 40 years of continuous habitation, all eight blocks are scheduled for demolition, to be completed by 2016. But how is this passing of a community and place reflected within Glasgow's thoughts and Glasgow Museums' collections?

Originally representing the glorious future of modern living, the flats were a dramatic physical representation of social change taking place. They went on to host great changes in the communities living within them, becoming home to students, nurses and refugees, among others. Perceptions and opinions of the Red Road have changed too – 41 years on from completion we are now thinking of the flats in the past tense, a past that brings up a mixture of emotions and thoughts – some mourn the flats' passing while others celebrate their end.

Glasgow was peculiar in the UK in that it adopted the high-rise block like no other local authority. The speed, enthusiasm and political force with which high-rise blocks were built meant that they shot up all over the city. They were, in part, the answer to slum conditions that had long beset many areas of the city, replacing overcrowded, unhealthy and crumbling tenements and houses that were well past their rent-by date.

Living memory is what sustains museums – it is the life-blood of outreach activity and the process of community engagement. Glasgow Museums has the tools and resources to collate, capture and record current changes between departments and through objects, however the Museums Service had previously missed the opportunity to actively collect and mark the changes to the cityscape and social context during the tenement clearances. With the Red Road Flats Cultural Project (RRF) we are seeking to redress that balance by being proactive rather than reactive.

Glasgow Museums's response to the RRF will be achieved through the Red Road Legacy Project – integrated cross-departmental collaboration which capitalizes on the flexibility and responsiveness of outreach activity whilst aiding curatorial, research and collections management departments to make direct connections with the communities that can bring immediate meaning to the collections. These skills are readily available to us but the trick is to blend them in a coherent way that helps engage with communities in order to collect material that reflects their experiences and stories.

By doing this, it is hoped that the Red Road Flats collection will be built through community consultation, partnership and understanding, both within the Museums Service and the community.

What is being planned here is not original or cutting edge. Arts organizations have previously taken the lead in the Red Road area. Smaller and far less bureaucratic in nature, they were on the ground for a number of years before we became involved. Organizations like Streetlevel Photoworks have hitherto supported projects recording communities' thoughts and attitudes to the place where they live. So what can we learn? What makes a museum outreach department unique within the field of arts provision is that we are about objects.

The OM believes there is a clear role for community-based outreach work, not only to engage with changes within the city but to become the channel through which these changes are recorded. Outreach activity is central in building, developing and challenging the collections that museums care for. This is particularly so in terms of contemporary collecting. The museum as an institution has to be more responsive to its audiences and has a duty to collect and engage potential future audiences. The OM's outreach work can ultimately have a direct input into Glasgow Museums' human history collecting priorities and future displays at the People's Palace.

Destruction and construction changed the cityscape as the old tenement blocks were cleared and the new high-rise towers grew. Of course, tenement life continues today alongside high-rise living. Tenements today are a popular and desirable form of housing. Several reminiscence kits are available at the OM covering the theme of traditional tenement life. Objects include stair chalk, used for delineating the edges of stairs within the dark tenement buildings. These resources were created many years after the mass clearances of tenements and go someway to reflecting – and marking – the changed cityscape and evolving communities. The RRF project offers up the opportunity to build on existing collections and stories by adding a new chapter after tenement life. By using outreach services and approaches to build meaningful two-way relationships, we can create new handling kit resources on the way to developing a community-focused museum collection.

Outreach activity is often the first encounter a community may have with a museum service. Some people remain unaware of the very existence of museums. There is limited value in the OM striving to engage with those who 'can't, don't, or won't' come to museums if we cannot nurture the development of the museum collection in response to the feedback we encounter.

The OM's original key value was in taking the museum collections out into the community. But our value, in this project, lies in bringing the community into the collection. This seems the right and appropriate time for the OM to be reflecting upon its own role and place within Glasgow Museums' service.

Opposite, above left: traditional tenement flats break the skyline on the right of this picture. Many families in tenements could expect a revolution in living conditions in the new flats at Red Road.
© Mitchell Library

Opposite, above right: looking north on Glasgow's Red Road in 1925. Within 40 years farmland made way for the tallest flats in Europe. Dramatic urban changes need to be reflected in Glasgow Museums' collection.
© Mitchell Library

Opposite, below: the first Red Road block was finished in 1966. There were 1,350 dwellings; home to around 4,700 people. Over the years attitudes to the flats have changed radically.
© Newsquest (Herald & Times)

MAPPING THE CITY

One of the most powerful and enduring symbolic means through which a city is understood is through the production of maps. Maps are complex objects. They can help us to locate places and ourselves in space. The production of a map is a political act, and suggests a way of seeing, communicating, organizing and understanding the world in which we live. In this sense, maps are about power – who gets to produce maps and what they say about places are of interest but so too are the silences and omissions within maps. What other experiences and views of the city are hidden, forgotten or suppressed in the production of a map?

The City of Glasgow has been mapped in a number of ways, reflecting in part the dichotomous nature of the city. Maps can be found which highlight the wealth of tourist attractions, heritage and entertainment to be found throughout the city. In recent years, Glasgow has re-imagined itself from a city of industry to a city of tourism and entertainment. This new visioning of the city, encapsulating 'the style mile' and accolades of City of Culture, City of Music, alongside the reshaping of the city's financial district and a reconfiguring of the urban landscape, with the demise of 'council' high rise flats replaced with 'luxury apartment living', presents a map of a cosmopolitan and economically thriving city. Other maps illustrate the economic, health and social inequalities within the city, for example identifying the many areas of multiple deprivation. These maps present conflicting accounts of Glasgow in the twenty-first century. However, they do not reflect the many Glasgows known to many of the city's inhabitants. The engagement with 'other voices' pinpoints a key objective of the OM, to encourage the participation of those traditionally identified as 'hard to reach groups'. How do these 'other voices' speak of the city? What do their maps of the city look like? What can they tell us of the Glasgows which are not represented in the many official maps of Glasgow – the tourist; the electoral; or Scottish Index of Multiple Deprivation maps? The contributions in this section reflect the dynamic, contested nature of the city. The essays recognize how 'where' we are relates to 'who' we are. This relationship is complex and at times problematic, as judgment can be passed on individuals due to their location, as described in the 'G15', 'Hidden Histories' and 'Gallus Glasgow' projects.

A participant in 'G15' indicates the impact of 'where' on life chances, commenting 'they see your postcode and you don't get the job.' 'G15' explores notions of territoriality and portrays the complex relationship that young people have with gang culture in the city. Providing a sense of identity through both belonging and exclusion, gang culture translates into where and when young people can move about their local community. The right of members of the community to represent their experiences of the city through maps was challenged during this project due to concerns over the image of Drumchapel projected through the production of the map. The power of maps is illuminated in G15 through the denial of the right of the young people to represent their lived experience of Drumchapel. The concern for image and a final stark reading of the map of G15 contrasts with the process of exploration and discussion involved in its production. Did the objector in effect 'see the postcode' without considering the deeper issues explored through the young peoples' efforts?

Originally conceived as a means to engage the local Pollok community with Glasgow Museums' collections, the writers of 'Pollok Kist Community Museum' illustrate the challenges which emerge in working with communities. Issues of representation

between professionals and communities, but also within communities, surface as they reflect on whose vision shapes the museum. The opportunities afforded through community engagement for participants are eloquently recounted in 'Hidden Histories'. Describing the evolution of a local history project into an award winning exhibition by the Easterhouse-based local history group Trondra, the story highlights the skills and experiences to be gained in unearthing the history of local places. Reclaiming the history of Easterhouse challenges contemporary views of this place as 'just a scheme'.

'Travelling across the City' highlights further the hidden histories of the city. Moving beyond the walls of the traditional museum space, the OM transforms the everyday places – shopping centres, health centres, community halls – and the not so everyday places – prisons – into sites where these hidden histories can be shared. The very fabric of the city is used as a starting point to retell the story of Glasgow in 'Sandstone'.

The writers and artists of Glen Ochil prison offer us an 'Alternative Guide to Glasgow' through memories of their own past in the 'Gallus Glasgow' story. In doing so, they flag the power of maps as a means of creative expression – as one participant observes, 'there's a lot mair tae be said ...A lot to tell an say an show'. The theme of territorialism is raised, highlighting that the experiences of the younger men of G15 are not new within the city. Their experiences of the production of the map not only challenge who has rights to represent the city and in what manner but illustrate the importance of the process and practice of making maps.[1]

Each essay reflects a way of seeing and experiencing Glasgow – revealing that there can be no one map of Glasgow which sufficiently represents the city in all its diverse and complex forms. In doing so, they ask us to consider how Glasgow's citizens can be meaningfully engaged in the shaping of their city.

Nicola Burns
Policy and Research Officer, Glasgow Life

References
[1] Kitchin, R and Dodge, M (2007) *Rethinking Maps, Progress in Human Geography*, 31, 3, 331–344.

'Ultimately, the Open Museum collects people and not objects; a measure of its effectiveness should be the growth of that collection not just in terms of numbers but in the quality of thousands of personal transformations brought about.'

David Hopes, former Open Museum Outreach Officer

'My experience as Arts Development officer for the south west of Glasgow is that we, as arts professionals, need to explore and use novel ways of "mapping" what communities are doing and how people in them are interacting with each other. We need to learn to have a dialogue with these communities and use that information to inform our practice and guide our delivery. We need to pay attention to what people are saying and do something about it or we risk creating a gulf between the communities and their services...'

Jon Pope, Arts officer, South West Area, Glasgow Life

TRAVELLING ACROSS THE CITY

The Open Museum on the Move

Community festivals and events provide fantastic opportunities for us to take objects out of the museum environment – from puffer fish to mbiras, they offer a fun, first point of contact with the public and other professionals. It is a way to support community initiatives – in community centres and parks – and extend our networks across the city. It gives us an opportunity to engage with individuals who are not part of an organized group, and have conversations initiated by objects, to listen to people and find out more about their interests, knowledge and aspirations and their relationships with the community, the city and its services. In other words, it allows us to informally map their lives and it often results in us learning new things about the objects, getting fresh ideas for kits, new borrowers for the loan service, other venues for travelling exhibitions and developing potential partnership projects.

Opposite, above: members of the public taking a look at the The Seventies reminiscence kit at a community centre in Ruchazie.

Opposite, middle: Lyndsey and John facilitate a 'Museum Takeover Day'at the Molendinar Community Centre.

Opposite, below: Staff member from the Cranhill Beacon getting into character at the opening of the Gruffalo display.

Left, above: OM staff talk to members of the public at a 50s event at the People's Palace.

Left, middle: Ewan McPherson discussing the *Schools, Then and Now* kit at Martyrs' School .

Left: Former Outreach assistant Babar Saleem talks to children about the OM Sports kit at a Special Olympics event.

'I was a fan of the OM's portable displays and touring exhibitions that tackled difficult or controversial contemporary topics in tactful yet uncompromising style, such as "Putting the Boot in", "Football Fans' Bus", "Bigot Busters" and "Bottle or Breast". I remember taking a display on contraception (Choices) to a Friday night youth club. I watched surreptitiously throughout the evening as one by one youngsters sidled over to have a look. Such displays inevitably have an effect on young people in gentle, subtle and immeasurably beneficial ways.'

David Hopes, former Open Museum Outreach Officer

Above, left: Putting the Boot in travelling display.

Above, right: Sargam travelling display.

Left: the *Caley* travelling display.

Right: Dzien Dobry travelling display.

Opposite, above: Football Fans' Bus travelling display at Woodside Library.

Opposite, below: Pastimes travelling display at Govan Cross.

Exhibitions on the Move

The city is full of stories. Travelling exhibitions enable stories to be told in one part of the city and travel to others to be heard. Over the years these exhibitions have explored the city in different ways – what it is made of, the history that lies beneath the streets we walk down daily, the industries which have almost disappeared from the landscape, celebrations of different cultures who live in the city, its citizens' memories and life experience. They have explored issues such as breastfeeding, homelessness, sectarianism and the wearing of the hijab, interpreted individual points of view and encouraged dialogue around the city. The objects are selected and explained by the people involved.

These exhibitions are taken to libraries, health centres, shopping centres, community centres, prisons and community festivals. The creation of such travelling exhibitions presents particular challenges to the design and technical team. It is a constant negotiation between the ideas of the community group and curator, the care of the objects and conservation recommendations, and creative and museum design standards. Weight and size have to be considered so exhibitions can be lifted and moved on a regular basis, on trolleys, on the van tail-lift, up ramps, through doors, in to a wide range of non-museum venues.

The OM has 20 travelling exhibitions on the move at any one time, enhancing the experience of the thousands of visitors to these community venues every year. They directly impact on the groups involved in making them and those who are involved in public programmes centred around them. The following pages reveal these travelling exhibitions and describe two of them; *Sandstone* and *2000 Glasgow Lives* in more detail.

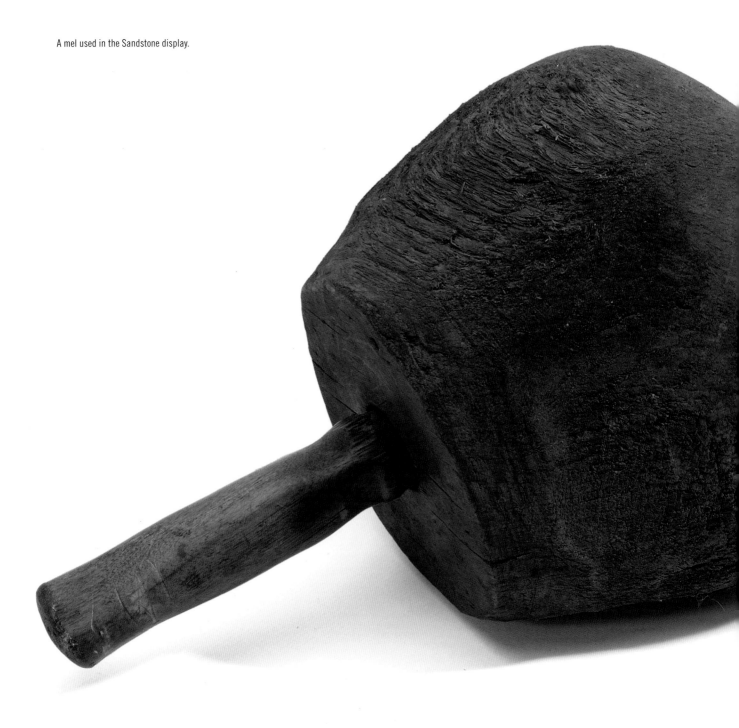

A mel used in the Sandstone display.

Sandstone

Alex Robertson and John MacInnes

FACTS

*S*andstone provides a glimpse at the geology of Glasgow from quarry to tenement. Back in 1994 the OM was based in Hagg's Castle Children's Museum. The workshop was based in the old stables building in the castle grounds. At this point in its history the OM was funded by Glasgow City Council's Social Work Department, who identified a percentage of the OM's partners. They asked us to work on a project with the now closed Balrossie Residential School near Greenock, which was a school for boys aged between 8 and 15 who were considered to be in need of special support due to personal, emotional, educational and behavioural problems. Balrossie wanted to build better relations with their local community and needed a display that could be easily moved around, a goal which defined the type and size of the final exhibit.

Right: the papier mâché display 'rock'.

The project began as a partnership with Balrossie. Alex Robertson, curator of the project, visited John MacInnes' workshop along with the group of six boys and their teacher while he worked on 'Tenement Life 1', one of the OM's earlier reminiscence kits. 'Sandstone' was the theme of the project because the school buildings, which dated from 1899, were built from sandstone blocks. The task was to produce a travelling display illustrated with text and photographs which explained the processes involved in quarrying and building with sandstone.

The boys were brought to the OM's workshop to meet John and talk through the project. John was then able to begin the creative process of designing a tabletop display, beginning with the basic idea of a box of objects, disguised to look like a sandstone rock. Gradually the box shape, made from plywood, was transformed with the addition of chicken wire, modroc and papier mâché. It gradually grew and our group visits to various sites gathered objects to enhance the museum artefacts and images. We visited a building renovation at John Anderson College beside the Western Infirmary and the lads got their hard hats and bibs and were introduced to 'auld

Alec', the company stonemason. They watched him chipping away with his mel and chisels and asked lots of questions.

Next we went to a local sandstone quarry. The boys' interest grew as a result of this visit – they enjoyed the bus ride and massive conveyor belts, but most of all the explosions! To this day *Sandstone* is the only OM display that contains dynamite, courtesy of the quarry, which also donated the rock samples. We then took the boys to a stonemason's workshop in Yorkhill and the three lads who worked there gave us old chisels and grinders. By now the display was taking shape and the youngsters began to refer to it as 'oor box'. Simon Gilmovitch, the OM's then graphic designer, created the finishing graphics which included the boys' drawings and text.

Working with educational establishments means adapting to their timetables. As this project ran across both an Easter and a summer holiday, the scheduling had to be precise and deadlines had to be agreed to allow enough time for all the necessary research trips with the boys, but this was achieved through effective teamwork with the school.

The display was launched at Kelvingrove in a specially organized exhibition to support Glasgow's bid to become the UK City of Architecture and Design, which we subsequently won. It attracted much attention, not least from the famous sculptor, George Wyllie, who complimented John on his workmanship and imagination. The exhibit, which is still in good condition, continues to travel round the city.

TOTALLY RANDOM: HINGED DOORS / DRAWER CASES
HINGED CASES / ENCASED CASES : LUMP OF SANDSTONE
REALLY STRONG WEIGHTED BASE – KIT BUILT IN
LAYERS ABOVE THE BASE – PROBABLY LARGEST
AND HEAVIEST OBJECTS ON LOWER LEVELS.

Left: one of John's early sketches.

Opposite: the finished display, ready to go on tour to the community venues.

'One thing that struck me was he did not use any machines, he did it all by hand.'

Balrossie School Pupil

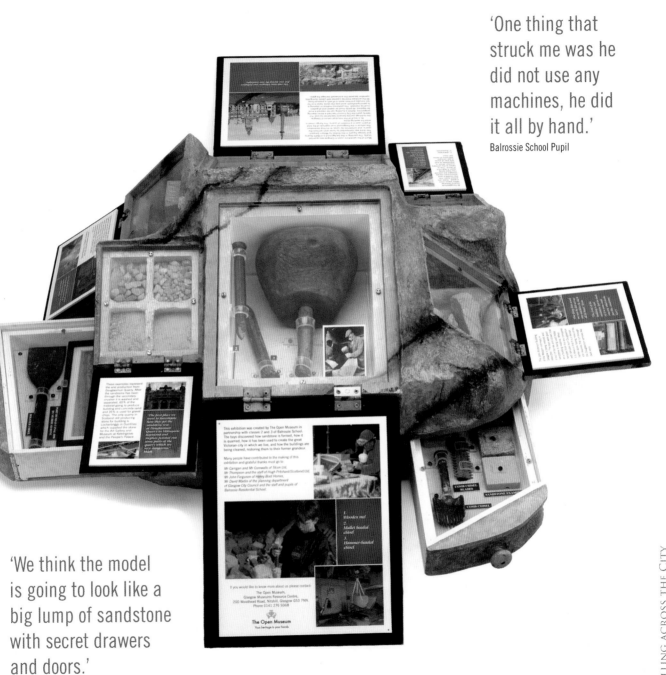

'We think the model is going to look like a big lump of sandstone with secret drawers and doors.'

Balrossie School Pupil

In the late 1990s, as the new millennium approached, the OM decided to conduct a series of interviews with Glaswegians in order to capture the voices and views of citizens. Initially the hope was that 2,000 interviews would be recorded, although ultimately this proved to be too ambitious. At that time oral history methodology was beginning to be used more widely, helped by cheap portable recording equipment being more widely available. Researching along themes of World War II, domestic lives and schooldays, this project utilized the efforts of a range of volunteers and was able to record the memories and views of more than 300 people.

The respondents were recruited through two methods – an advert in the *Evening Times* newspaper and through information postcards that asked for contact details which visitors were able to pick up from the Enquiry Desks across all Glasgow Museums' venues. The majority of interviews, which took place over a period of about two years, were conducted by volunteer interviewers who visited the respondents in their homes, in large care homes, and in community centres. The interviews were recorded onto cassettes and text extracts were taken for use in the accompanying exhibitions.

2000 Glasgow Lives includes some significant information, such as an interview with Dr John Brown of John Brown and Company shipbuilders and an interview with Glaswegian author Robert Douglas. There are also contemporary aspects to the collection, including interviews with musicians involved in the Glasgow music scene of the 1990s. The project collected written testimonies as well as photographs or ephemera from the interviewees.

The majority of interviews were conducted with members of the public from a wide range of social and economic backgrounds. The oldest interviewees were over 100 years old and the youngest were teenagers. Occupations ranged from lace tambourer to engine driver, secretary to psychiatrist, as well as a nurse, shop keeper, a museum technician and a slew of taxi drivers. Within the collection there are also three sets of family contributions, individual interviews with a husband and wife, which are very important for researchers looking at family relationships or the phenomenon of 'social memory'.

The *2000 Glasgow Lives* project now forms part of a two-year Knowledge Transfer Fellowship project funded by the Arts and Humanities Research Council (AHRC) which aims to digitize, catalogue, and summarize this and other oral history archives held at GMRC. The testimonies will also be analyzed and extracts made which focus on the nature of work and workplace cultures and how these have changed over time. As a consequence of this project the oral history collections within Glasgow Museums will be revived, thereby providing a resource that will be widely available in various formats to museum staff, academic and local historians, schools and the general public. It will also encourage new interpretations of Glasgow's recent past that interrogate and challenge collective myths such as that of 'Red Clydeside' and the 'sectarian city.' This project expands the existing collaborations with Glasgow Museums and allows for the transfer of knowledge on oral history methodology, theory and practice.

David Walker

Participants:
Members of the public
Number of participants:
301 (257 audio interviews,
42 video interviews and 2
written submissions
Location:
Interviewees' homes /
residences or workplace
Duration:
Over 250 hours of recordings

FACTS

'One summer some of the men
in the close got together and
made us a huge sandpit which
was filled courtesy of Lilley the
Builders. I'm not sure whether
Mr Lilley knew he was our
benefactor but we were very
grateful to him nevertheless.'

 Jean Wilcock, born in Springburn, moved to Drumchapel with
her parents in 1959.

Left: a *2000 Glasgow Lives* display at
the Knightswood Community Centre.

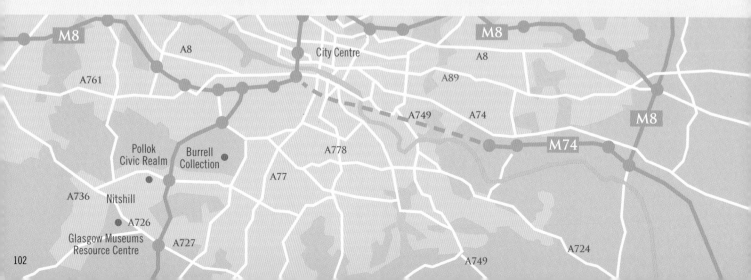

FACTS

Participants:
Pollok Kist Group
Number of participants:
10
Location:
Pollok Civic Realm
Duration:
2000–ongoing

'I love it [the jug] best in spring when I can fill it with daffodils. It makes me smile.'

Pollok Kist Group member

Opposite, left: ceramic jug, *c.* 1940s Mary's own jug, made at Govancroft Pottery, Glasgow, links to the history of Glasgow's potteries.
OMLI.2008.1.2

Opposite, right: the jug on display in the exhibition.

Opposite, below: the location of the Kist at the Pollock Civic Realm in relation to GMRC and the Burrell Collection.

The Pollok Kist Community Museum (PKCM) offers 'history on your doorstep', as one visitor said. That history is told by local people who are passionate about the history of their area. Through their stories and experiences they enable others to connect to Pollok's past – an area that hosts a constantly evolving demographic and which has seen radical change in its built environment.

The PKCM is also a significant milestone in the OM's history. It was developed in 2000, the mid point of the twenty-year context of this book. It extended the work of the OM beyond handling boxes and travelling exhibitions into a permanent space. It also created the opportunity to involve local people in developing exhibitions that were important to them and in making decisions about what to include and how those exhibitions are presented. Some of the volunteers have been with the project since the beginning – an extraordinary commitment for a volunteer group.

Pollok, which is in the south-west of Glasgow, was chosen for this unique development because research[1] had shown that people in Pollok did not visit Glasgow's museums, in particular the Burrell Collection, geographically the closest museum, in particular. Various reasons were identified, including a lack of transport amidst perceptions that the Burrell was not intended for local people. To counter this, and to make a connection with local people, a community museum was proposed.

[1] Carried out by Lowland Market Research. www.lowland-research.co.uk

Heritage lottery funding over a three-year period enabled the purchase of quality museum display cases and the fit-out of an area in the Pollok leisure centre, which at the time was the area's main social and recreational space, housing the library and sports facilities. The funding also supported an outreach officer for three years, to recruit and work in partnership with a group of local volunteers. Publicity days were held at the local shopping and lifelong learning centre. Participants were recruited by advertizing for people interested in local history and this has framed the focus of the group since then.

'A number of our volunteer members joined the group in October 2000 because we wanted to learn more about, and help bring the area's fascinating history/heritage to the community.

With the help and guidance of the Open Museum staff, the first exhibition Pollok through the ages – which included subjects like the early settlers' folklore and witches, the great estates, Lord Darnley and Frederic Lobnitz and the Victoria pit disaster – has been followed by five more. The current exhibition includes ancient dwellings, pawnshops, cafés, pottery, wildlife and 'onion Johnnies'. We have acquired a variety of skills including how to develop and implement concepts for exhibitions and how to conduct research, and over the years the group has also visited a number of other Scottish museums to obtain ideas for display and presentation of exhibits.

These visits have been extremely useful to us. We have benefited greatly through our involvement with the Kist, and have significantly enhanced our knowledge of local history and how to present it to the public, as well as gaining the satisfaction that the efforts of our group, and all the others involved, have been very successful.

The Open Museum has also benefited from the challenging ideas that we have put forward, for

example bringing humour into the displays, and we look forward to contributing to and participating in further Kist exhibitions and related activities. In summary, the Kist is a great idea which has worked very well and has brought history in a people-friendly form to the benefit of the local community.'

Ron Fleming, Kist member

'A lot of people wouldn't go to a museum in town, so it's good to have a museum locally that gives people information about their area'. Response from a visitor

'My recollection is the final day of installation and opening of the first Pollok exhibition in the leisure centre. We had hidden the exhibition behind some display boards and, as we removed these ready for our launch event, two young women with pushchairs approached and started to look in the display cases. One of them looked at the World War I embroidered postcards on display, got out her mobile phone and started talking to her father "You know those auld postcards you've got? You need tae get down tae the Leisure centre, they've got ones just like them on show here."

I knew then that this project and the community museum space was going to be a success in overcoming the traditional barriers to engaging the local people with museums. Before we'd even officially opened, the local community were embracing this display as their own and making real and meaningful connections to their own lives, experiences and cherished objects.'

Christine McLean, first Outreach Officer (*c.* 2000–01)

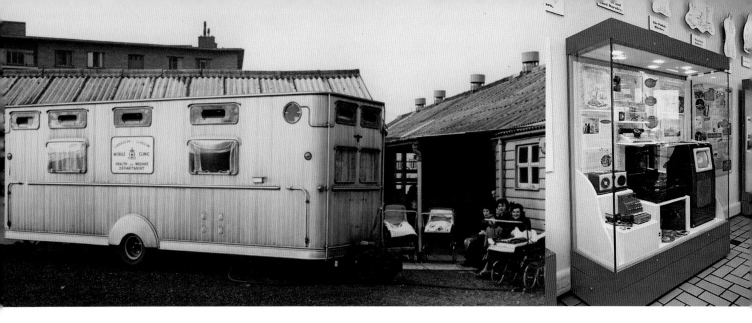

'The Pollok Kist has played its part in charting the upheaval that Greater Pollok has undergone in recent years, such as new construction, businesses, services, social initiatives and opportunities.

One of the milestones in the Kist's development was the publication in 2004 of the award-winning *Greater Pollok – A Picture history*. This for me marked a sort of coming-of-age, the first real recording of the area's history in accessible book form and an indicator of the project's maturity as well as a pointer perhaps to the way ahead for future archival projects. This was produced in partnership with Community Learning and in association with the Mitchell Library. This fantastic achievement was acknowledged when the volunteers received the Scottish Adult Learning Partnership Award.'
Peter McCormack, Outreach Officer, 2002

This ten-year period has mapped the incredible long term relationship between an institution and a local community volunteer group. The volunteers who originally got involved because of an interest in local history have found themselves caught up in wider challenges and change. These include the transition from the HLF-funded phase to being part of the OM's many and varied city-wide commitments. It includes wider questions of how to develop a sustainable model for a community led museum; how to negotiate the boundaries of support and ownership in a context where, unusually for Scotland's independent and community museums, it is supported financially and in kind by a local authority and does not hold a collection of its own.

Above, left: 100 years of health: looking at personal and public health; hospitals nursing home and institutions. Image depicts a mobile ante-natal clinic, in 1950s Pollok.

Above, right: the 1950s – a decade of change, a look at the changes to various aspects of life in Glasgow in the 1950s.

Left: Greater Pollok: A working life focusing on the mining, chemical production, farms, quarries and factories which employed local people over a century ago in this area. © Illustrated London News

Changes in civic organization in Pollok has seen the PKCM move in 2009 into the Pollok Civic Realm, which integrates the old library and sports centre into a new model of urban civic organization. It includes a nursery, a stress centre and the Citizens Advice Bureau next to the health centre. The new, busier space has created the opportunity to get more people involved in sharing stories and experiences for a growing and more diverse audience.

Development in Glasgow Museums has seen the Burrell Collection, as with other Glasgow Museums' venues, create its own unique audience development plan, which includes its responsibility for engaging its local audience.

GMRC, which houses 80% of Glasgow Museums' collections, has been established just up the road and is actively building relationships with the local community – Pollok now has the world's history on its doorstep, with endless stories waiting to be told.

Left: Otter currently on exhibition at the Pollok Civic Realm

COMMENTS

The Pollok Kist changed the Open Museum big time and for the better. We had been flirting with 'mini museums' for a while when [the Kist] came to fruition. Suddenly, with top notch cases, came better objects, conservation help and I had to learn to work to very accurate and unforgiving tolerances.

John MacInnes, design and technical officer

Margaret went to the stores at the Open Museum to pick her objects for the next exhibition. She felt like Alice in Wonderland and wanted everything that came to hand Remember the case is wood not elastic. If you take all of that John will have a fit so cut it down and get out of here. You can be Alice again in another year.

Margaret

Being a member of the Greater Pollok Kist and working with museum staff over the years has proved to be an enlightening, rewarding and educational experience for me, and hopefully these sentiments will continue.

Mick Doherty

Initially I joined the Pollok Kist because of my interest in the history of Greater Pollok. I had been a collector of model buses for many years and had massed a total of 300 buses, many from different parts of the world. So, when the opportunity arose to display them in the Kist, I felt it would be a chance to let the public see them, well some of them. Since then, they have been on display in the Burrell, Auld Kirk Museum Kirkintilloch and Glasgow Museum of Transport.

Rab Doherty

The Pollok Kist volunteer group decided to introduce humour to their first 2001 exhibition Pollok through the ages. This took the form of caricatures, cartoons, and text. This decision was by the Open Museum.

At the official opening of the exhibition in 2001 Councillor Liz Cameron, chair of Culture and Leisure services praised the Kist for introducing humour a first for this type of exhibition. She also suggested we incorporate humour in our future exhibition. To date this has been the case.

Robert Cardle

Knowledge of local history is great for all ages. We all benefit from our past generations history. Having young and old come to see our displays is exciting for them and us. Today's generations is tomorrow's history. The Kist is full of history that many people can relate to. The older generation like to see the old photos and artefacts of Pollok.

Kathleen and Gordon Richards

The current exhibition includes ancient dwellings, pottery, weaving, the Carbeth hut community and wildlife on the local River Cart.

The OM supports four other permanent museum exhibition spaces in Cranhill, Springburn and Glasgow Central Mosque.

'After 20 years, the OM has nothing to prove, it was and remains a major success, and is part of Britain's museological history.'

Peter McCormack

Left: Horse-drawn traffic coming off the Govan ferry c.1957, from *Transport, a journey through time:* which showcased the history of flight, from the biplane to the space shuttle, the age of steam on the railways, the canals and puffer trams and buses, the Glasgow subway and much more.

Above: image of a hut at Carbeth from the current exhibition at the Pollok Civic Realm.

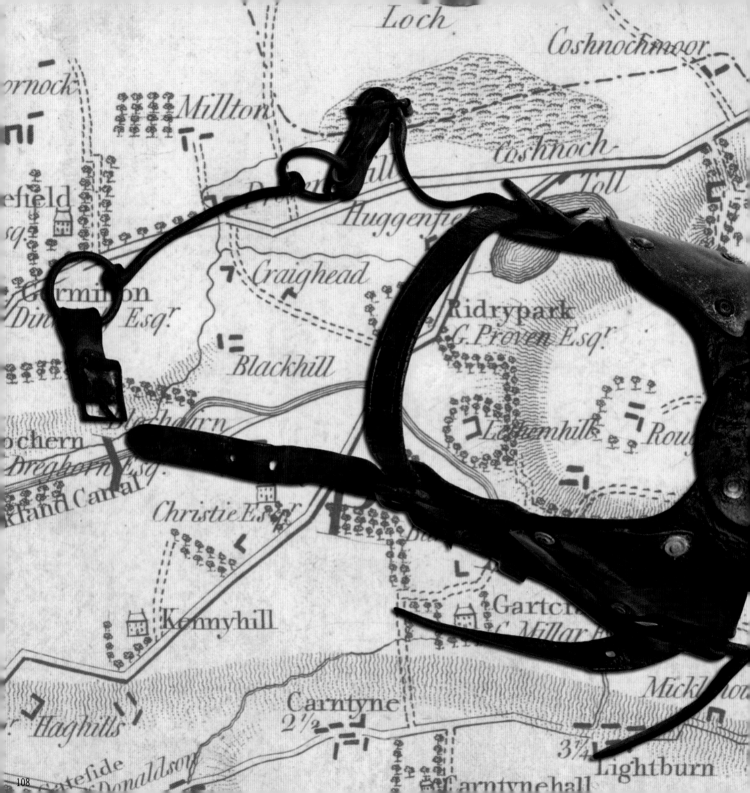

Greater Easterhouse – More than just a scheme

FACTS

Participants:
**Trondra Local
History Group**
Number of participants:
10
Location:
Easterhouse
Duration:
**Development phase
2001/02 exhibition
2002–09, web-based
exhibition current**

The Trondra Local History Group (Trondra) grew out of a local investigations module at John Wheatley College, based in Easterhouse in the east of the city. When they first came together in 2000 the participants, all local residents, knew little about the history of the area in which they lived. They approached the OM and suggested working on an exhibition about their local history. From the outset they were such a committed and hard-working bunch of people – a real inspiration to everyone they worked with. It was a great experience to watch them from the early days just starting out and finding their feet as researchers and becoming confident, award-winning historians.

Old maps and photographs, street and place names, all hold fascinating clues to a history before the present housing schemes were built on the edge of the city at the end of World War II. There had been villages surrounded by flax fields and communities working as weavers, on farms, in mines and along the canal. Provanhall House is a medieval country house located in Easterhouse's Auchinlea Park. The group spent many hours with the caretaker of Provanhall, Steve Allan, becoming familiar with its religious, royal and ghostly residents. Many fascinating stories linked to Glasgow and Scotland's history were revealed along the way.

Head protection or harness for a pit pony, National Coal Board issue.
PP.1987.11.[1]
Map © National Library of Scotland.

Trondra discovered fascinating things about the area's early history – Stone Age flints and a Bronze Age spearhead and burial cairn that had been unearthed locally. A strange island which had appeared in nearby Lochend Loch as the water level dropped during temporary drainage in 1931 had turned out to be a 2,000 year old crannog. Hazelnut shells, pottery and woodwork, bone, animal teeth and an ancient quernstone used to grind corn all gave an insight into the lives of the crannog's inhabitants. This crannog was one of many in Scotland constructed on lochs from local resources to keep families safe from enemies and animal attacks.

Exploring history exposes you to different ideas and ways of doing things – different types of housing settlements, family organization, use of local resources, sense of community, diet, employment conditions, attitudes to children and elders. On the journey back in time you encounter alternate religious beliefs, the wisdom of old farming practices, the injustice of land distribution, periods of optimism and raised expectations, movements of populations, attitudes to mental health and ways of dealing with conflict. It creates opportunities to ask questions about how things are being done in the present and offers tools to make choices, changing and shaping the future.

Trondra worked with the OM to tell these fascinating stories, unravelled through the course of their research, to a wider audience. They selected objects from the museums' collections and lent some of their own, sourcing and selecting images and writing text for panels and labels. They discussed with John MacInnes, the OM's Design and Technical officer, what their exhibition – *Hidden Histories* – might look like, and visited the workshop to see it all take shape. It was built in sections with the hope that once the exhibition had been on show in the local college it could then also tour to other local venues.

The group also included a section on local heroes – people with local connections who personally inspired a member of the group. It featured those who have made a difference in their communities – stood up for what they believe in, spoke out and acted against injustice, believed in the potential of young people and created opportunities for them to realize that potential.

Trondra learned much about the local area, its history and past residents but also about themselves too. A strong sense of place, identity and belonging promotes positive mental health. Achieving something that you never thought was possible, which could be

shared with your family and community, and with the world via the world-wide web, was a fantastic boost to self confidence.

The exhibition, displayed at John Wheatley College, generated a fantastic sense of achievement. The wider community of Greater Easterhouse benefited from the experience as well, not just the members of the group, as Trondra gave people reason to feel pride in their local community and raised awareness about the rich history of the area, countering the often negative image portrayed in the media of poor housing, high crime rates and lack of amenities. Trondra went on to produce a website which enabled the exhibition to be accessed worldwide. Supported by the OM's Neil Bristow they also produced a book – *Hidden Histories* which was proudly accessioned into the collections of the National Library of Scotland during a special ceremony. They became role models for others.

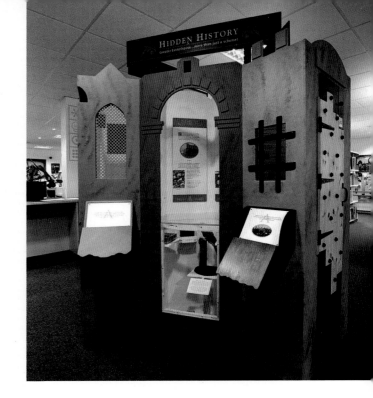

Opposite, left: Former outreach assistant Norma Tennent helps John to paint the Hidden History display.
Opposite, centre: Mounting objects for the display.
Opposite, right: Trondra Local History Group with curator Laura Murphy.
Right: Hidden History on display at John Wheatley College, Easterhouse.
Below: sketch for Hidden History workers' grill.

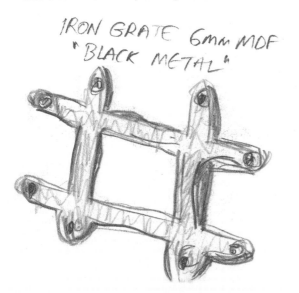

IRON GRATE 6mm MDF
"BLACK METAL"

COMMENTS

The opening of this exhibition was my first OM experience – I was to start my new job with them in a few days time. It seemed a long way out from the city centre … but what I remember most is the buzz, warmth and pride of everyone involved.
Chris Jamieson

Hidden History was my favourite Open Museum project. My dad actually grew up in that area and I loved being able to phone him and tell him all the amazing stories that the group uncovered during their research.
Laura Murphy

A flames hat, acquired for the display case.

An image taken by a participant.

They see your postcode and you don't get the job... Believe in yourself...

FACTS

Participants:
Young people age 16–18
Number of participants:
10
Location:
Right Track, Drumchapel
Duration:
October 2004–March 2005

'Pressure can lead to depression and affect your mental health.' Participant

When the OM's partnership with Right Track began in 2004 the media was full of headlines about young people. Those who congregated on the streets were identified by local residents and media as problematic and threatening and were linked to a rising public fear of crime. The Antisocial Behaviour (Scotland) Act 2004 extended anti-social behaviour orders (ASBOs) to people aged 12–15 years, and other solutions came in the form of increased surveillance and the infamous 'hoodie' ban – young people being refused entry to shopping centres wearing hooded tops and government rhetoric on 'respect'.

Above: the water tower in Drumchapel.

The OM had been approached by the organization Right Track in Drumchapel to work with a group of young people aged 16–18 on an exhibition, which became 'G15'. Right Track aims to assist disadvantaged young people in Scotland to improve their opportunities in obtaining employment through training and work experience placement programmes. The programmes are designed to develop aspirations, self-esteem and self-confidence and address the low levels of literacy and numeracy among clients. Our intention was to create an exhibition that would support Right Track's way of engaging with young people and also expose participants to different workplace environments, behind the scenes in the museum. This approach came out of good professional networking: Right Track had previously worked on a project with National Galleries of Scotland (NGS) and had realized the positive impact the project had had on the young people involved. They wanted to build on this work. The OM's curator had met the senior outreach officer at NGS earlier in the year and recommended that Right Track contact us.

Right Track matches the young people with a range of different programmes that they offer and within the programmes the participants can select different options. A group of six young people opted to be part of the project.

The group made an initial visit to GMRC and made a tour of the pods, exploring the collections. They met Learning & Access staff, the arms and armour and natural history conservators in their workshops, and design and technical staff, as well as the volunteer coordinator who discussed potential placements. Inspired by this they thought about their own exhibition.

After much discussion the group members decided on the theme of 'gang culture', a central part of their own lives. They thought it was something many people in Glasgow would be able to relate to and that it would attract an audience. The decision to adopt gang culture as the theme meant the young people were engaged with something they had chosen themselves but also that there was only a short time to prepare for what was an issue-based exhibition. In preparation for the project the curator met with youth workers in the area and made a visit to FARE[1] in the east of the city, a community-led project with an excellent reputation for positive ways of tackling territorialism and related violence.

Early discussions centred round the bravado of gangs and online research around weapons was quickly channelled into a programme which would, more seriously, enable the young people to examine identity and life choices. The group explored current and historical maps and images of the local Drumchapel area and were fascinated by being able to zoom in on their streets using Google Maps, sparking discussions around how these streets were divided into territories. One member created a coloured photocopy of the map, highlighting the young people's perception of the gang territories in the area, with the colours starkly marking out allegiances and safety of movement. Some of the areas were incredibly small.

We walked round the locality, translating that map into the reality of the streets and what it meant for all the young people involved – true to the map, some of them refused to walk down certain streets. The group also took photographs of the places important to them – areas where they 'hung out' and discussed how they felt about where they lived and how they might change it. They looked at the positive and negative things about being in a gang, affirmative role models, choices and life journeys – and the importance of friends, peers and families in supporting them to reach their goals, as well as exploring the responsibilities and consequences of violence.

During the development of this project the participation and support of the Right Track staff member was vitally important. She knew the young people: was engaging, empathetic and supportive; lived locally so could help shape discussions and challenge their thinking; and she was able to get underneath their bravado and exaggeration to make it a more meaningful learning experience for all. She could also manage their behaviour, within the Right Track ground rules, so again they got the best out of the project.

The 'G15' exhibition included objects and clothing that the participants selected as important to their identity and a series of banners of photo-montages, images and words from the workshops and text from newspaper headlines. They wanted to engage audiences with the impact of marginalizing and demonizing young people, the importance of a sense of belonging, friendship and having someone look out for and respect you.

The exhibition was intended for venues and events where it would inspire discussion about the issues. Does where you live affect your life choices? What role does the media play? Could the positive energy and companionship be harnessed in a way that would be beneficial for the community? Can well thought-out youth programmes which engage with

the root causes of challenging behaviour make a difference? What do people think about restorative justice?

Ultimately the project had to be very flexible – the group changed, people had interviews for and undertook work placements and returned. The individual who had originally approached the OM moved on soon after the project began. On the morning of one of the sessions, the army had organized a recruitment day for young people. These challenges could be absorbed by the flexibility of the project.

The young people had represented their reality through their own images and voices. They were honest and clear. They were not accepting of it but understood how it framed their opportunities. They had ideas of how they would change it and what needed to be in place for them to reach their aspirations.

A local politician who happened to see the display out of context before it reached its intended venues saw it as presenting a very negative view of the area and did not want it to be shown. Despite pursuing other options for its exposure, ultimately the decision not to show it at all meant that the work was not able to inspire the wider discussion it had been created to encourage.

[1]Family Action in Rogerfield and Easterhouse.

Below: K-Swiss shoes, leather, used in the display.

K·SWISS

'Where we live can affect our life choices and opportunities.'

Participant

An excerpt from The Alternative Guide to Glasgow, as created by HMP Glenochil residents.

'High Street' by participant

What Glasgow Means To Me
By Danny McAlpine

When I was born,
I tasted it with my first breath
It was the first thing I ever saw,
smelt, heard or tasted.
I bathed in its waters
I ate its food
I went to its schools
I played in its streets
I reached puberty there
I wore its clothes
I walked its streets
I worked its factories
I saw its sun rise and set
I saw its seasons
I saw its times change
I became part of it
It became part of me
I fathered its children
I travelled its buses
I basked in its summers
I shivered in its winters
I belong to it
It belongs to me
I will live my life out in it
In sickness and in health
'Til death do us part.

FACTS

Participants:
HMP Glenochil residents and Gowan Calder, Writer in residence
Number of participants:
14
Location:
HMP Glenochil
Duration:
January–April 2009

'There's a lot mair tae be said... A lot to tell an say an show.' Fred N

Glenochil's writer-in-residence, Gowan Calder, worked with men from Glenochil prison throughout the 'Gallus Glasgow' project, supporting and encouraging them in their efforts. Made aware of the OM following recommendations from an acquaintance working with Museums Galleries Scotland (MGS), Gowan approached us with an interest in our reminiscence and object handling resources, as an aid to focusing and inspiring the men's writings and artworks. As we already display collections within the library of Barlinnie Prison, the OM met this approach with real interest, both excited and confident of the impact collections from Glasgow's past and present could have on the prisoners and their project.

Her Majesty's Prison Glenochil is sited near Tullibody in central Scotland and holds long-term adult male prisoners with High, Medium and Low supervision security classifications. It provides opportunities for addressing offending behaviour, including a range of work and education facilities. The 'Gallus Glasgow' project was initiated and led by a collection of inmates attending Glenochil's art and creative writing courses. Sharing a desire to explore and revisit memories of the city that many had at some point in their lives called 'home', the men worked together throughout 2008/09 to draw together writings, artworks, and reminiscences that told a story of Glasgow that is often overlooked.

Left: the Open Museum's van arrives at HMP Glenochil.

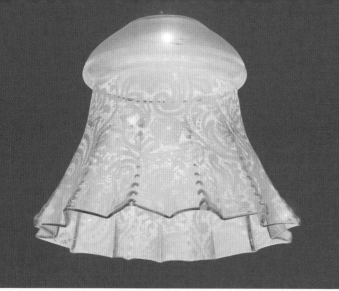

'When I was a child, I lived in Cranhill in the East End of Glasgow. To some a scheme, to me it was my own little world.'

Danny

Left: 'Which way up?'
Glass lampshade from the 'Tenement Life' reminiscence kit.
Made at Cooper's City Glass Works, Glasgow, *c.* 1910.
PP.1975.138.4

We made the first of many 70-mile round trips to HMP Glenochil at the beginning of January 2009. Greeted by snow on the Ochil hills, we entered the prison with very little idea of what to expect. Under Gowan's wing, Claire and I were guided down in to the heart of the prison, passing through security check after security check, before reaching the Education and Recreation wing where the attending prison guards offered a healthy mix of curiosity and suspicion at what might lie within the mysterious box that was the 'Folk and Folklore' handling kit. As the men began to arrive, offering appreciative greetings, there was an unmistakably warm welcome. Mostly aged in their 50s, though with a sprinkling of younger men, they hailed from across Scotland. Each man traced a part of his history back to the streets of Glasgow, a place where some had not set foot since their last days of freedom in the 1960s.

Initially the men looked to us for information about the objects we brought along in the OM's handling kits, but soon the older ones began to lend their voices more freely to the mix, carrying discussions down a track of reminiscence and debate about 'the way things used to be'. While the younger men listened on obediently and examined pipe clay within the 'Tenement Life' kit, the elder participants spoke authoritatively on the tiniest details of the tenement lifestyle, confident that this was their history to write. 'No, no, the lampshade definitely went this way up!' Their sessions stirred memories and questions of their city with the objects providing a platform to explore avenues that many may not have felt immediately relevant to their experiences of Glasgow. These fresh ideas and unexpected reminiscences would later feed into the group's work on their project during subsequent sessionswith Gowan.

Before the OM's involvement with the group, a number of the older men had already created a series of fantastic artworks, poems and essays.

However, Gowan had come to notice a reluctance and lack of confidence amongst the group's younger men when putting their ideas and memories to paper. She felt that it was a lack of belief in their own communication skills and literacy levels which continually frustrated their efforts. As the project unfolded, a fresh approach was taken in the hope of overcoming this stumbling point.

Taking inspiration from the men's obsession with the 'where it happened', the OM suggested the use of a map throughout sessions, so that they could physically mark down their object-inspired memories with doodles and graffiti-style notations. We invited the men to literally fill in the blanks of Glasgow's story, and by April 2009 the map was full.

Taking confidence from their days chatting over museum objects, the men had found their own way to tell their story.

As might be expected, the prison environment can be quite unpredictable, and this often had real effects on the morale and esteem of the group who saw fellow group members being unexpectedly transferred to prisons at the other side of the country with seemingly only the shortest notice. In addition, an overhanging doubt about the future of Glenochil's Learning Centre left everyone involved wondering whether we might even get to complete the project. Intimidated by the task of putting their memories on to the page in the form of essays, poems and stories, the idea of using the map of Glasgow as a canvas upon which to paint their own detail proved a real success and helped the men gain greater confidence in what they had to say, and what they could write about this 'jigsaw' of a city.

Claire Coia and I were also touched by the inmates' genuine appreciation for the doors that the 'Gallus Glasgow' project had opened up to them. Members of the group were keen to volunteer their newly learned computing skills to the project, while others were so eager they began writing their stories right in the middle of their sessions with the objects. Inmates also benefited from simply being in an environment where, for an hour each week, they could shed their status as prisoners or criminals and just be a group of guys with something to say about their city.

Right: painting of the Fish Market by a participant.

PERSPECTIVES: BEHIND THE OPEN MUSEUM

Julian Spalding • Nat Edwards • Morag McPherson

T he Open Museum was a crucial aspect of an integrated strategy to turn Glasgow Museums as a whole into a responsive service. By the time I arrived in Glasgow as director, I had had a great deal of experience in outreach, such as running and initiating travelling community exhibition programmes, picture lending services and many community involvement projects, for Durham, Sheffield, Manchester and the Arts Council of Great Britain. Though many of these did excellent work, their limitation was that they were essentially spoon-feeding – dishing out what we thought the public would like to see. There was and still is nothing wrong with this – 'you don't know what you want until you get it', as the song goes. But in Glasgow I wanted to go further. So I invented the concept of the Open Museum, not as a separate service, but as an integral part of the whole.

People do not visit galleries and museums mostly because they are not interested in them. Fair enough. But that does not justify a laissez-faire attitude on the part of the museum. People think they are not interested in things for all sorts of reasons – class, religion, education, upbringing, culture, financial aspiration (they are all related) – and many of these prevent people developing interests that could enrich their lives, even change their lives. Museums and galleries are in the interest-generating business and they need to be continually reaching out to new audiences to do this. Peoples' interests are changing – not just the young but throughout society as a whole – and museums have to respond to these. If they fail to do so then people will not keep coming. But keeping up with changing interests is not just a strategy for maintaining visitor numbers.

Museums and galleries can do more than just tread water – they can help develop interests across society and, most crucially, extend and change those interests. They provide unique public places where people's interests can be encouraged, shown and shared. This is what St Mungo Museum of Religious Life and Art was about – it added something new to the public interests in the city – an interest that was already nascent, but did not have a public platform nor any means to nurture growth. This was a museum born out of community consultation – it had to be; the museum could not be dictatorial about other people's beliefs! This is what I wanted the whole of Glasgow Museums to become – interest-generating places that were responsive to the interests (even if currently in-articulated) of their potential public. To do this, we had to learn from the people who did not visit. That was what the Open Museum was about, what its job was within the Museums Service as a whole.

The Open Museum was not simply an extension of what we were doing – another outreach service – I had tried enough of them. Rather it was crucial to

the future direction the whole Museums Service was taking. That was why I set up the Open Museum as soon as I could after I arrived and why the head of this service was always on the Management Team. We needed to know who did not come and where our potential was for development as we reached further out into the community we served. The Open Museum was not just about breathing out but breathing in. It was the Museums Service's lungs and listening post. Its job was to bring people into the museum, find out what interested them, and enable them to take exhibits that interested them out into the community. The Open Museum was developed in close conjunction with the Social Services and Education Departments in Strathclyde Regional Council, and being myself a Chief Officer of the City I was able to get support for this innovative project at that level from the Chief Officers of these services. This opened many doors into communities we might not otherwise have reached.

The Open Museum had many successes in its early days – I remember, for example, a brilliant show put on by a women's group in Easterhouse about what men have made women wear down the ages and in different cultures, from scold's bridles to Chinese foot-bound slippers. But I knew that the Open Museum could not really become fully operational until the whole Service itself had changed, until all curatorial, conservation and registration staff paid more than lip-service to the principle of increasing safe access to the collection, but actively sought new ways to do this. I knew, too, that the Open Museum would not become fully operational, and much bigger than it was then, until my new ideas for a central, accessible Resource Centre for the collections was achieved, and, above all, my concept for a remodelled Kelvingrove.

I started rethinking Kelvingrove as soon as I arrived – the team working on that project soon became known as the Dream Team (such was my staff's not unreasonable assessment of my aspirations). Unfortunately circumstances prevent me realizing this dream, which was to re-invent the concept of the Victorian encyclopaedic museum in twenty-first century terms – not just using modern technology and thematic displays (though both are important) but, most crucially of all, by bringing all the curators nearer to their public. The idea was that each would be responsible for different 'island' displays – not just responsible for their curation and creation. But more importantly they would be responsible for the public's response to them – and, even more crucially, for changing their displays so that they worked better with the public. Easily and cheaply changeable displays had to be part of the design brief – the modern equivalent to the Victorian showcase.

My intention was that many of these displays in Kelvingrove would have been first created outside the museum, in the community, by curators developing displays with their communities using the good offices of the Open Museum. My ambition was (and I would have realized it in time!) to have every curator throughout Glasgow Museums (and other members of staff, including Museum Assistants) working on at least one Open Museum project all the time. That is how big the Open Museum was to become – not as a small separate service working, gamefully, on the margins, but as a small enabling service, working in the core of the museum, with many, many projects, at all levels of development, generating interest outside the museum walls, throughout the community and within the museums themselves. Above all it was to be the heartbeat of the service, in the melting pot of community interest that was my dream for Kelvingrove. The Open Museum was conceived of as a way of opening out the museum as a whole – the means by which the museum would

flower and grow within the potential interests of its community. The Open Museum was not a museum in itself, but an attitude of mind – the drop of nectar in the flower that makes its petals open and attracts the bees.

Julian Spalding
Edinburgh, 2010

For naturally conservative institutions, museums spend a lot of effort trying to adapt to their environment. In my own twenty-four years in museums, I have numerous memories of management consultants and strategic planning workshops – albeit ultimately blending with each other. Change management always seems depressingly predictable. At some point, inevitably, someone will ask you to name the strengths of your museum. Predictably, the litany of museum strengths will be recited – 'our collections; our buildings; our people'. Yet these institution-defining strengths are also our constraints. The structure of the collections will tend to influence the outlook of the organization. The buildings nail the service down into locations ballasted by legacies of geography and deep-rooted semiotic messages. The organizational and social cultures, attitudes and values of staff, volunteers and museum publics can engender bewildering obstacles to innovation. The excitement of Glasgow's OM for me was that it was an attempt to challenge the most fundamental constraints faced by a museum – and by doing so, create chances for the Museums Service as a whole to change.

When I joined the OM as the first Senior Curator in 1993, it had already enjoyed a three-year pilot. My appointment marked its establishment as a core department – part of a wider restructuring of the city's Museums Service by Julian Spalding. Discussion of the OM in the press had focused mainly on the fairly obvious topic of access – that it was taking the city's collections to new audiences – but Julian's vision for Glasgow was more transformative. An organizational restructure had broken the connection between collections and buildings – creating instead four city-wide curatorial departments, of which the OM was one.[1] The strongly thematic, cross-disciplinary St Mungo Museum of Religious Life and Art was due to open and plans were soon under way to create the Gallery of Modern Art and redevelop the People's Palace and Kelvingrove. At the same time, the example of initiatives such as Springburn Museum had increased demand in the city for community museums and a new model was needed to extend local ownership, without locking into unsustainable buildings and collections. The OM provided a radical solution. With it, Glasgow sought to create a community museum that could draw upon any part of the city's collection and which could exist anywhere. No longer confined to a dusty corner of a municipal building and a few rusty objects – the community museum could showcase the very best of the UK's finest civic museum collection – and display it, in an imaginative and provocative way, in the places that the community actually visited. By doing this, the OM opened a whole Pandora's Box of museological problems – of conservation; security; documentation; governance; curatorship; in some cases even public taste. By forcing the Museums Service to solve these problems, the OM provided an opportunity for the organization to learn in a way that no management consultant could ever dream about.

I loved my time at the OM – but I do remember upsetting a lot of people. We upset the tabloids – 'Bar-L Cons Pick their own Art Treasures!' screamed one headline.[2] We upset the politicians – I was personally carpeted by one Lord Provost for featuring a display on S&M and the limits of consent,

beautifully-illustrated by artwork from the Burrell Collection.[3] Most of all we upset our colleagues. We constantly created seemingly impossible problems for them – trying to put sensitive objects into the hostile environment of a swimming pool foyer; giving convicted criminals access to our most secure object stores; giving design and curatorial decision-making control to people with no training or experience and then expecting our professional colleagues to make some order from the ensuing chaos. Because they were such good professionals – and lovely people besides – nearly every single one of them met the challenge with a smile. Even more remarkably, the impossible became easier to achieve – as we hammered out new solutions and new systems.

Of course, the OM helped to demonstrate that, by extending new forms of access, people could get real benefits from museum collections – there is hard, published research to prove it.[4] People in care demonstrated faster recovery – linked directly to participating in an OM Programme. Research with participants in the Pollok Kist demonstrated significant increase in personal capacity and confidence – people who had long since abandoned formal education returned to college after taking part in OM projects. Just as important, however, is the fact that, with the OM, doing impossible things became part of the day-to-day business of Glasgow Museums. No matter how the shape of the city's museums changes in the future – if the museums' people preserve the belief that, every day, they can do impossible things, then I feel that upsetting them was worth it.

Nat Edwards
Director, Burns National Heritage Park

References
1 The four departments were Art, History, Science and the Open Museum – each represented on Glasgow Museums' Management Team.
2 The *Evening Times* after HMP Barlinnie prisoners were invited to visit Glasgow Museums to select objects for an exhibition within the prison – in partnership with the prison Education team.
3 In an exhibition in partnership with the first ever Glasgay! Festival.
4 See (2002). *A Catalyst for Change: the Social Impact of the Open Museum*, London: RCMG. www.le.ac.uk/museumstudies/research/Reports/catalyst.pdf [Accessed 16.08.10]

The OM requires a leap of faith – on the part of participants, who are often being asked to take on something where they can have no idea if it's actually going to be useful, interesting or beneficial to them; on the part of museum professionals who sometimes have to let go of the things they were trained to do and instead hope for the best; and on the part of the Council which funds a service where most of the real difference it makes is beyond capture. But what the OM demands in faith, it also delivers, giving many people over the last twenty years faith and confidence in the ability of museums to enter into dialogue with communities, pause, reflect and do things differently.

My time at the OM began and ended with two staging posts in its development. When I started, the research into *Catalyst for Change* was being completed. By the time I left, the OM team had delivered their own review of the purpose of its creation, in response to the expansion of community engagement throughout the organization and the evolving nature of community provision in Glasgow.

These two staging posts – the search for evidence that the community engagement work museums undertake has an impact on the lives of individuals further down the line, and the attempt to position the work where that impact could be at its greatest – characterize the ongoing process of refinement that the OM undertakes, trying to understand its own effect and how it can be developed further. In between there was an immensely enjoyable mix of people, collections, challenges (not always enjoyable) and achievements. Longer term relationships with communities were

established through the Pollok Kist and Springburn Community Museum, taking the OM in new directions.

Many of the significant developments in Glasgow Museums at this time reflected the principles on which the OM had been established. Kelvingrove represented a move towards a museum based on dialogue. The public were consulted in depth and on a large scale about what they wanted from the museum, and a number of displays were developed in partnership with community groups. Open Museum displays on difficult subjects, such as Violence Against Women, were made visible by being included in one of the city's most prestigious venues. Glasgow Museums Resource Centre, where the OM became based, was a huge leap in opening up access to collections. The application of the OM's principles of access to GMRC makes it, along with the Science Museum's Darwin centre, the most accessible large museum store in the world. The new Education and Access department (now Learning & Access) expanded the community engagement work of the service beyond the OM team, so that all venues have systematic processes of working with their visitors and neighbourhood residents.

Despite the fact that this was a period of the principles and practice of the OM being embedded more widely in the organization, on a day-to-day basis it often did not feel like that. Introducing people and objects into situations where they previously had no place (sometimes by accident, sometimes by design) involves challenging a lot of preconceptions. Sometimes it can be a reasonable negotiation, at others it feels like a clash of cultures. A little bit of conflict is necessary to make progress, and this is the role that the OM was happy (sometimes a bit too happy) to provide – a thorn in the side of all those who think they know what a museum is. The OM has written its own template, through years of negotiating how details of conservation, design and other processes affect who gets to say what and how they get to say it.

It is in all the technicalities of these processes that values are deeply embedded, and where they need to be challenged. Constant reiteration and defence of its principles in relation to details was, and I'm sure still is, the OM's daily diet. It would be great to know about all the changes, big and small that the OM has effected – the interest in a subject that might have been sparked by a casual encounter with an OM stall at a festival, the boost in confidence from working on a project that might have led to someone signing up for an evening class, the sense of local pride that someone felt that led to them taking their grandchildren to a museum for the first time – but the true successes of the OM are beyond our grasp. There is enough evidence to suggest it works, just how well we may never truly know, but we must keep the faith.

Morag McPherson
Principal Learning and Community Officer,
Tyne & Wear, Archives & Museums

THE CONSERVATION CONTACT ROLE

Lindsay Robertson and Seoyoung Kim

The aim of the OM Conservation Contact is to provide conservation recommendations and treat objects where necessary, so that while the museums collection can be enjoyed by a wide range of people in either handling kits or display cases outwith the museum, we can also ensure that our collection is protected for the enjoyment of the many generations to come. The role of conservation contact for the OM is a very interesting one. I took up the post in 2009 at the same time as World Culture Assistant Conservator Katie Webb – we spend one day a week on OM conservation tasks. The conservation issues are very different to those faced in my usual role as Assistant Conservator of Furniture and Frames and involve working on a wide range of objects, some of which are used in handling kits, where over time, wear and tear and damage occurs. Along with the assessment of objects for venue displays, I have carried out conservation treatments on a diverse range of objects, made from wood, metals, plastics and rubbers.

Right, image 1: Close up of degrading rubber handle with interior metal strap.

Right, image 2: Handle with applied cramp to adhere the rubber and metal to each other.

Right, image 3: Plastazote block holding the woven polyester material to the underside of the handle.

Right, image 4: Handle after conservation treatment.

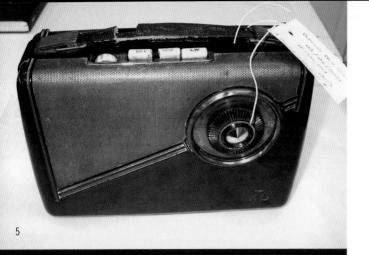

5

'As a conservator I care for the physical and technical condition of the object, understanding it as a 'witness' from the past to inform and educate future generations. Experiencing the beneficial impact of the Open Museum's work by facilitating objects or part of the collection to local communities has given me a much broader sense of purpose: caring for society starts with caring for its heritage...'

Stephanie de Roemer, Assistant Conservator of Sculpture

One of the first objects I worked on was a KB radio set which is part of the '1950s Music' reminiscence handling kit. The rubber covering the metal handle had badly degraded and movement during handling had resulted in parts of it lifting from the interior metal band, crumbling and being lost. In future we will avoid including objects with vulnerable materials like this in handling kits, however it was decided that it would be better to treat this object so that it could remain in the kit as a key object and thus avoid replacing it with a similar item in better condition. The challenge was to repair the handle to halt the degradation of the rubber, which would continue even if in store, but is hastened as a result of handling. I decided to consolidate the rubber to the interior metal band with an acrylic resin that would penetrate between the cracks while remaining flexible enough to allow movement. This was cramped with a clear polyester film cover (melinex) to prevent the resin sticking to the cramp block. The lower side of the handle was then covered in a strong fine-woven polyester material and a reversible Polyvinylacetate adhesive was used to adhere it using blocks of melinex covered polyethylene foam plastazote to hold it in place. The repair was then disguised using pigments to match with the colour of the handle. I decided not to infill the areas of loss as the idea was not to restore the object to its original condition but to stop it from degrading further. The fact that the damage is visible will also alert future handling groups to the fact that it is a fragile museum object which requires careful handling. The condition of the handle strap will be checked on a regular basis to assess its condition. However the conservation treatment will hopefully ensure that no further losses occur and the radio can continue to be enjoyed by many.

Lindsay Robertson - Assistant Conservator of Furniture and Frames, Glasgow Museums / Glasgow Life

I worked for Glasgow Museums until the summer of 2008 as Assistant Conservator (metals, arms and armour) and was the Conservation Contact for the OM in 2006/07.

My role was to provide the initial frontline conservation advice and recommendations on conservation issues, including condition assessment, treatment options, display methods and preparations for display. I collaborated with other conservators as necessary on specific matters, and communicated between the OM staff and Conservation Department, by reporting information on an individual basis or attending Section meetings.

I was fascinated by the scope of work which the OM undertook and found their work rewarding and meaningful. I was also impressed with the enthusiasm displayed by the OM staff about their work and their creativity in maximizing their often limited resources. Most of all, it was great to see all sorts of objects from the past and present being used for in their handling kits and displays. These were often objects from storage which would not otherwise be seen. The OM gave these objects new meaning and relevance. I learned many new things about people's lives in the past through working on these objects. It is always a pleasure to see rather understated objects re-gaining appreciation. My particular favourite handling kit was the 1950s reminiscence kit. Being involved in the OM also gave me the opportunity to meet people and go to places which I would not otherwise have been able to (like the Glasgow Central Mosque).

However, at times it was often challenging to achieve a good balance between the demands for access to these collections and the appropriate care required of any museum collection. The nature of the OM's work required a flexible, practical and often rather unconventional approach. There were certainly plenty of issues which might instil some fear in conservators' hearts! Many objects were exposed to extensive handling without supervision, subject to the attached risks of theft and physical damage. They were also often displayed in undesirable environments.

My experience of the OM showed me that what was needed was realistic and achievable conservation advice for safer access to collections. I felt there was a need to have a more visible and recordable communication channel between the OM and Conservation Department. An Object List Form with conservation recommendations was introduced and the objects in many handling kits were documented and numbered.

The experience enhanced my understanding of the use of collections and gave me the opportunity to learn to have a broad and flexible approach as a conservator. It remains one of my proud achievements of my time with Glasgow Museums.

Seoyoung Kim - Metalwork, Arms and Armour Conservator, The Wallace Collection, London

Opposite, image 5: a KB radio.
Below: the 1950s music kit.

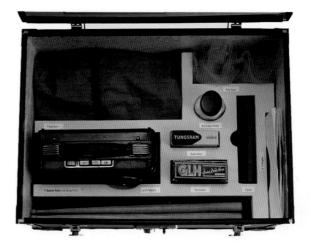

BIBLIOGRAPHY

Mark O'Neill

References to the Open Museum

American Association of Museums. 'Collaborative Projects, AAM handout, #3' bit.listserv.museum-1 [accessed 01/08/2010]

Atkinson, R (2010). 'Co-creating displays with the public'. *Museum Practice*.

Barr, J (2005). 'Dumbing down intellectual culture: Frank Furedi, lifelong learning and museums'. Museum and Society, 3/3:98–114. www.le.ac.uk/ms/m&s/Issue%208/barr.pdf [accessed 16/08/2010]

Barr, J (2005). *The stranger within: on the idea of an educated public*. Rotterdam, Sense Publications.

Carnegie, E (1996). 'Trying to Be an Honest Woman: Making Women's Histories', in Kavanagh, G (ed.). *Making histories in museums*. Leicester, Leicester University Press.

Dodd, J, O'Riain, H, Hooper-Greenhill, E, Moussouri, T, Sandell, R (2002). *A catalyst for change: the social impact of the Open Museum*. https://lra.le.ac.uk/bitstream/2381/24/1/catalyst.pdf [accessed 01/08/2010]

Economou, M (2004). 'Evaluation strategies in the cultural sector: the case of the Kelvingrove Museum and Art Gallery in Glasgow' museum and society, 2/1: 30–46. www.le.ac.uk/ms/m&s/vol_2,1.html [accessed 01/08/2010]

Edwards, N (1995). 'Sleuths in Sauchiehall Street'. *Museums Journal*, 11:22.

Edwards, N (2001). 'Glasgow's Open Museum: adventures in a box'. *Interpret Scotland*, 3:7.

Edwards, N (2000). 'Ten years of the Open Museum'. *Museum Practice*, 12:22–26.

Fitzgerald, L (1996). 'Hard Men, Hard Facts and Heavy Metal: Making Histories of Technology', in Kavanagh, G (ed.) *Making Histories in Museums*. Leicester, Leicester University Press.

Graham, M (2004). 'Volunteering in heritage, Volunteering as heritage ', in Graham, M, and Stebbins, RA (eds). *Volunteering as leisure/leisure as volunteering: An International Assessment*, CABI, pp.13–30.

Hayes, F and Kirrane, S (1993). 'Do it yourself', *Museums Journal*, 2:29–30.

Heal, S (2008). 'The other within'. *Museums Journal*, 108/4:22–27.

Hooper-Greenhill, E (1994). 'Museum education, past, present and future', in Miles and Zavala (eds). *Towards the Museum of the Future*. London, Routledge, pp.133–146.

Kavanagh, G (2001). 'Buttons, Belisha Beacons and Bullets: City Histories in Museums', Kavanagh, G, and Frostick, L (eds). *Making City Histories in Museums*. Leicester, Leicester University Press, pp.1–18.

Keene, S (2005). 'Out of the darkness'. *Museum Practice*, 105/8:26–29.

Keene, S (n.d.). 'Museum Collections: Treasure or Trash'. www.suzannekeene.info/articles/treas_trash.rtf. [accessed 01/08/2010]

Lynch, B (2001). 'If the museum is the gateway, who is the keeper?' *Engage Review*, 11:1–12. www.engage.org/downloads/152E22BED_11.%20Bernadette%20Lynch.pdf [accessed 01/08/2010]

MacDonell, M (1991). 'Open Museum Controversy'. *Museums Journal*, July, 10–11.

Martin, D (1996). 'Mobile museum case study: the Open Museum, Glasgow'. *Museum Practice* 3:60–63.

Martin, D (1998). 'Multimedia case study: People's Palace Museum, Glasgow'. *Museum Practice* 9, 60–61.

Martin, D (1999). 'Education special: outreach to schools'. *Museum Practice* 11, 59–60.

Mastoris, S (1999). 'Outreach special: Museums Reminiscence Network'. *Museum Practice* 11, 94–97.

Merriman, N (2004). 'Involving the public in museum archaeology', in Merriman, N (ed.). *Public archaeology*. London, Routledge.

Munday, V (2002). *Guidelines for Establishing, Managing and Using Handling Collections and Hands on Exhibits in Museums, Galleries and Children's Centres*. www.mla.gov.uk/what/publications/~/media/Files/pdf/2002/handling_collections.ashx [accessed 01/08/2010]

Newman, A, and McLean, F (2004). 'Capital and the evaluation of the museum experience'. *International Journal of Cultural Studies* 7/ 4:480–498.

Newman, A, and McLean, F (2006). 'The Impact of Museums upon Identity'. *International Journal of Heritage Studies*, 12/1:49–68.

Newman, A, McLean, F and Urquhart, G (2005). 'Museums and the Active Citizen: Tackling the Problems of Social Exclusion'. *Citizenship Studies*, 9/:41-57.

O'Neill, M (1990). 'Springburn: A community and its museum', in Baker, F. (ed.) *Writing the Past* (pp.114–126). Lampeter Press.

O'Neill, M (1991). 'The Open Museum'. *Scottish Museum News*, Winter, 6–7.

O'Neill, M (1994). 'Museums and the Renegotiation of Identities'. *Museum Ireland*, Vol.4, 1994.

O'Neill, M (1995). 'Curating Feelings; Issues of Identity in Museums'. *Turning Inside Out: Report from the Canadian Art Gallery Educators Symposium in Alberta*, November 1994. Reprinted in Sub Rosa, Toronto, May 1995.

O'Neill, M (1999). 'Museums and their Communities', in Lord, B and Lord, G (eds). *Planning Our Museums*. HMSO.

O'Neill, M (2002). 'The good enough visitor', in Sandell, R (ed.). *Social inclusion in museums*. Leicester, Leicester University Press, (pp.24–40).

O'Neill, M (2006a). 'Museums and identity in Glasgow', in *Heritage Studies*. 12(1), 29–48.

O'Neill, M (2006b). 'Essentialism, adaptation and justice: Towards a new epistemology of museums'. *Museum Management and Curatorship*, 21, 95–115.

O'Neill, M (2007). 'Kelvingrove Art Gallery and Museum, Glasgow, Scotland: Telling stories in a treasured old/new museum'. *Curator*, 50(4), 379–400.

Pez, J (2002). 'Glasgow to benefit from the creation of a £7.4m open store'. *Museum Practice*, 21:8a.

Stokes, A (2000). 'Scottish Museum kits bring learning to life', in *EL Gazette*, 242:10.

Valentine, J (2008). 'Narrative Acts: Telling Tales of Life and Love with the Wrong Gender'. Forum: Qualitative Social Research 9/2 Article 49. www.qualitative-research.net/index.php/fqs/article/viewArticle/412/895 [accessed 01/08/2010]